Brush Lettering made SIMPLE

A STEP-BY-STEP WORKBOOK TO CREATE
GORGEOUS FREEFORM LETTERED ART

Chrystal Elizabeth

LETTERING ARTIST

PAGE STREET
PUBLISHING CO.

PAGE STREET
PUBLISHING CO.

First published in 2018 by
Page Street Publishing Co.
27 Congress Street, Suite 105
Salem, MA 01970
www.pagestreetpublishing.com

Distributed by Macmillan, sales in Canada by The Canadian Manda Group.

22 21 20 4 5

ISBN-13: 978-1-62414-676-3
ISBN-10: 1-62414-676-7

Cover design by Chrystal Elizabeth
Book design by Page Street Publishing Co.
Illustrations by Chrystal Elizabeth

Printed and bound in China

Page Street Publishing protects our planet by donating to nonprofits like The Trustees, which focuses on local land conservation.

Dedicated to my amazing children

Isabel, Tyler, Jered, Aiden, Dean and Olivia.
Love you always.

And to the incredible lettering community

that continues to support and encourage
not only me but others too.

Contents

INTRODUCTION

Hi there! I am so thrilled that you have come across my book and are interested in furthering your brush lettering skills with me! I have been brush lettering for a few years now since I first started after my twins were born. It was the best creative outlet that I'd ever come across after trying other hobbies that didn't work out. Growing up, I always had a passion for learning different styles of lettering, and I ultimately fell in love with lettering all over again.

Since learning to brush letter, I have become known in the lettering community as someone who has always tried their best to share as much information as possible while learning new techniques. I do this because, when I first started, there was so little information available, and I know how difficult it can be to attempt new letter styles. That is also why I am so excited to have the opportunity to share a ton of that creativity and knowledge in this book. I can't fully describe how much this means to me, but it's a whole lot. I love sharing the things I've learned with new lettering artists and hope that by doing so, you'll experience the joy that I did when I first started out.

Please enjoy yourself while going through this book. Not only will you learn how to begin brush lettering, plus a bunch of new ways to brush letter, but you will also learn everything you need to know about brush lettering with watercolor. I have provided all the details, including recommended supplies and step-by-step techniques that will help you get the best results.

So, go on and get started! There's so much to learn. Thank you again for having me along on your lettering journey.

Chrystal Elizabeth

SECTION *one*

Basics
TO BRUSH LETTER LIKE A PRO

Welcome to the start of your brush lettering journey! In this section we'll go over everything you need to know to get started with brush lettering, such as what supplies to use and how to take care of them. You will also learn how to use your tools the right way while brush lettering so they'll last even longer. This includes how to create thin and thick strokes without damaging the tips of your brush pens—one of the most common challenges that frustrates many beginners.

Once you get the hang of all the basics, you will be able to use that knowledge and apply it to learning all of the different lettering styles that are included in this section. You'll even learn how to create stylish numbers and unique ampersands.

So, if you've ever wondered how brush letterers do what they do, you'll have a great understanding once you've gotten through this section. Brush lettering doesn't have to be something that's difficult to learn. As long as you take your time while going through each chapter and practice the techniques and different brush lettering styles, you will be well on your way to becoming a brush lettering pro!

Getting the Most Out of YOUR BRUSH PENS & BRUSHES

When I first started learning how to brush letter, I made a lot of mistakes in how I handled and took care of my brush pens and brushes. It's easy to rush into something that looks fun and exciting without doing the necessary research to make sure you're doing it all correctly, but that knowledge is very important for lettering. Without an understanding of the basics, brush lettering can get rough and really frustrating.

That being said, I hope to save you some of the frustration I experienced early on by sharing a few tips on how to use your brush pens and water brushes properly—not only to extend their life but also to get the best results from them.

We're going to go over how to use a large brush pen (Tombow Dual Brush Pen), a small brush pen (Tombow Fudenosuke—Soft Tip) and a water brush (Pentel Aquash Water Brush—Medium). You can always apply these tips to similar items you may have instead. Don't feel limited to what you see me using here. There are so many different brands and products available out there to try out, and I love using different pens and brushes. You can get different results depending on what you use, so experiment and see what works best for you. To keep things simple, I'll be going over just a few of your options in this chapter.

The most important thing to keep in mind is that the tips on some brush pens are made with fibers that can be easily damaged. Always proceed with caution.

I recommend using water-based brush pens for your brush lettering. I love using them because there are a lot of things you can do with them compared to the alcohol-based brush pens I'm aware of. Later in the book, we'll go over how to blend colors together, and water-based markers are best for this. You can easily blend them using just the brush pens themselves or blend with a water-based blending brush pen. You can even blend with just water and a watercolor brush or water brush to get a watercolor effect.

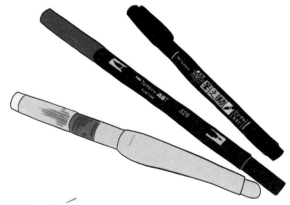

Alcohol-based brush pens dry very quickly and tend to be more permanent. They will work fine for regular brush lettering, but they aren't as easily blendable as water-based ones. However, you can blend them using alcohol-based blending pens. In general it takes a bit more practice to learn how to use them to blend effectively.

LARGE BRUSH PENS

Large brush pens are great to learn with. Some have firmer tips than others, which may be easier for some beginners to use initially. Examples of different large brush pens include Royal Talens Ecoline Brush Pens, Artline Stix Brush Markers, Kuretake Fudebiyori Brush Pens and Sakura Koi Brush Pens. The large brush pen I'll be referring to in this section is the Tombow Dual Brush Pen.

Large brush pens have tips that can fray easily. You may have already experienced this. The main issue, usually, is using them at the wrong angle or on any type of rough paper (even semi-textured paper may seem smooth enough, but it sometimes contains rough fibers that can damage the brush pen tips). But remember, even when you are careful with them, they are likely to fray after a good amount of usage anyway. However, knowing how to use them correctly can extend their life. These larger brush pens are a lot of fun to use, so don't be discouraged.

When it comes to paper, always use a very smooth variety. Something like premium printer paper (a favorite among myself and other letterers is HP Premium Choice Laser Jet Printer Paper), smooth Bristol paper, marker paper, Rhodia paper and even smooth tracing paper are all great choices. But keep in mind that not all premium paper is made equally. Don't be afraid to try different types and brands. Having a high-quality smooth paper to letter on will not only help extend the life of your brush pen tips, but it will also help you feel more confident as your pen glides and makes smooth transitions.

The other important thing is knowing how to hold your brush pen. Always hold it at an angle, letting it rest in your hand at a 30- to 45-degree angle.

If you're not great at remembering angles, like me, just remember that you don't want to hold it upright like this:

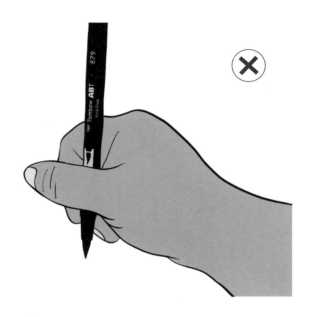

You want to hold it at an angle like this:

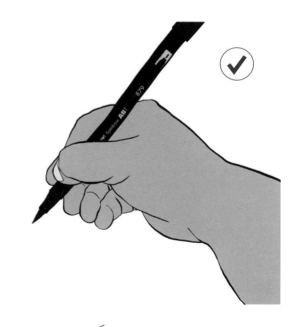

And again, this will not only help extend the life of your brush pen, but it will also help you achieve those fantastic thick and thin strokes.

Touch the tip lightly to the paper to get thin strokes.

And apply pressure to get the thick strokes.

SMALL BRUSH PENS

Small brush pens, including those like the Pentel Fude Touch Sign Pens and Zebra Disposable Brush Pens, give you a little more freedom to use your brush at a slightly more upright angle without completely damaging the tips. Although, if you'd rather be safe than sorry, always use them at around a 45-degree angle, just like the larger brush pens. I have unfortunately bent the tips of some of my smaller brush pens to the point that they never worked properly again. Once that happens, they're only good for practicing. I'm hoping this advice will save you from that learning mistake.

But if you have by chance started to slightly bend the tip of your brush pen, you can try straightening it by rotating the pen as you're lettering. Don't get me wrong though—bending the tip somewhat is required to get thick strokes; it's permanently bending the tip that you don't want.

I'll be referring to the Tombow Fudenosuke Pen as an example in this section. You'll notice I'm holding it just slightly more upright than I would normally recommend for the larger dual brush pen.

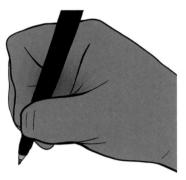

Although it's nice that these are a bit more durable than the larger brush pens, always use high-quality paper (such as the paper right inside this book!) to get the best results. But, just a quick note: I have actually been able to use these smaller brush pens on watercolor paper without damaging the tips. Just always use caution with textured paper.

When using this pen, touch the tip lightly to the paper to get thin lines.

And apply pressure to get thick lines.

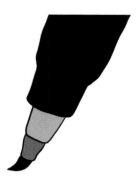

WATER BRUSHES

And lastly, water brushes. These are one of the first types of brushes I ever used (and fell in love with) when I started learning how to brush letter. It was the Pentel Aquash Water Brush to be exact. This was the perfect brush for me to practice with when I was first learning because I didn't have to remember to be as careful with it.

The Aquash water brushes are very durable. They have nylon brush tips and are so flexible that you don't have to worry about ruining them. I personally have some that have lasted for years. You have a lot more freedom with these to experiment with many different techniques.

Other similar water brush brands you can try are Sakura Koi, Caran d'Ache Aquarelle and Kuretake Fude, to name a few. There may be some that won't have the same nylon brush tip, so you'll want to keep that in mind and make sure to always look at the descriptions before purchasing them.

Water brushes can be used with both ink and watercolor. You may even notice people actually filling the water tube up with one or the other so they can have certain colors or mediums ready to use. I have one that is filled with black ink mixed with a little water that I only use for black brush lettering, others that are filled up with just water that I use for watercolor and some that are filled with colored inks that I use for brush lettering and watercolor paintings.

The other nice thing about these water brushes is that you can use them on any paper that can hold the water they release. They even work on the paper in this book and card stock, although you'll want to make sure to blot the tip on paper towels frequently so that there isn't too much water saturating the card stock paper. If you saturate the paper too much, it can warp or tear. If you're worried about the paper warping or tearing later on for other brush lettering work, you can always stick with some good quality watercolor paper.

My favorite paper to use with water brushes is 140-lb watercolor paper or mixed media paper. Mixed media paper is thinner and usually warps (Canson XL mixed media paper, for example, is only 98 lb), but I personally don't mind the paper warping when I'm using it.

Now have some fun and get a feel for your brush pens and water brushes on one of the border pages later in the book, the margins here or in a separate sketchbook. Write your favorite word. Just something that you think is fun to write. Come back once you're done with the book to letter it again and see your progress and how much you've accomplished!

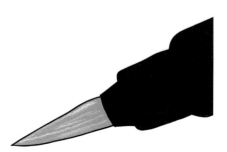

Practice
STROKES

It's always great to start with a good foundation. Especially with brush lettering. Learning how to establish basic strokes now will make it easier for you to form letters and flourishes later on.

When practicing your strokes at first, you may notice your lines are shaky. This is normal. Very normal. And if yours are not, that is amazing, and I would like you to know that I'm extremely jealous! For most of us though, the muscles in our hands and arms aren't used to making these types of smooth movements yet. But don't worry, practicing regularly will help. I usually recommend practicing every day when you're starting out on your lettering journey. It is so important. Practicing, whether it's just strokes or actual letters, is going to help you build muscle memory so that your hands and, more importantly, your arms will learn and get used to what they need to do. That way, in time, it will feel more natural and get even easier.

To be quite honest, my hands and arms still get pretty shaky. Usually it happens in the mornings, so I do warm ups, like the practice strokes on the next few pages, before I start lettering, to achieve the smoothest strokes possible. Practicing is key to getting better at brush lettering. Even when you think you don't need to practice anymore, it's still a good idea to keep at it. Just like learning and refining any technique, you have to keep practicing the basics to stay consistent.

Some other things to consider are making sure you're sitting up straight and staying hydrated. Always be sure to take care of yourself. Not only are you important, but bad posture and dehydration can affect your lettering. Having correct posture will help a lot with making smooth movements. Not many people realize that when you're brush lettering, you should be using your arm more than your hand, so always try to be in a position that lets you move freely and with ease.

PRACTICING STROKES

When it comes to practicing strokes, repetition is key. You want to do rows and rows and even more rows so that you get used to the movements—so much that it becomes second nature.

Let's go over what I feel are the most important strokes that will help you with your lettering.

LINES

The first strokes we're going to go over are lines. Straight, parallel lines. The first line is a downstroke and the second is an upstroke. Remember to take your time when doing these.

For the downstroke, you're going to use pressure the entire time. Make sure your pen is at an ideal angle and try to keep the line as smooth as possible.

And for the upstroke, try using just the tip and lighter pressure the entire time—the complete opposite of the downstroke. This stroke can be slightly more difficult than the downstroke. Even for seasoned letterers. It takes more discipline to use less pressure and still get smooth strokes.

When practicing these strokes, and the others too, try to keep them as consistent as possible and try to have consistent spacing in between.

TIP: Use graph paper if you need help with your lines and spacing. It's a favorite among most letterers.

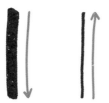

U STROKES

The second stroke we're going to practice is the U-shaped stroke. When doing this stroke, continue to apply pressure for the downstrokes and lighten pressure for the upstrokes.

The most important thing you want to try and achieve here is getting nice smooth curves. The best way to make this happen is to lighten your pressure as soon as you start the curve. Where you see the arrow in the example is where you want to start lifting your pen tip to create the thin upstroke. I also included an example of a broken U stroke so you can see where I start the transition.

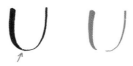

Knowing where to start the transition from thick to thin strokes should help you get smoother curves.

Don't get discouraged if this takes quite a few tries. Even hundreds of tries. I practice daily to keep my round strokes as smooth as possible, and I'm still not 100 percent consistent.

Try practicing the variations shown below.

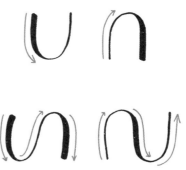

LOOPS

Next up are loops. Loops require the application of everything you've learned so far, but they're actually really fun once you get the hang of them and will make a huge difference in your lettering and even with flourishes when we get to that part later in the book.

You may be wondering why I'm having you practice all these variations even though they look so similar. I promise you, you'll see as soon as we get to practicing letters. I want to make sure you get used to all the variations we'll be using. Practicing the last loop you see below will actually help you with letters like the lowercase letter r and connecting strokes in the next chapter. That will also be the only loop stroke that you will keep completely thin the entire time.

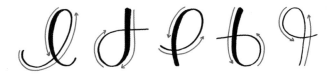

O STROKES

And for our last stroke, we'll be practicing O strokes. These are sometimes considered the hardest strokes to perfect in lettering. Especially if you were attempting something like traditional calligraphy.

With the O strokes, you want to try and get a smooth round line all the way around. You also want to try to connect at the same place you started for a smooth, finished look. Also, don't forget the other tips you've learned so far with the previous strokes. They will still apply here too.

When doing the counterclockwise O stroke, I like to start at the top, just before where the thick part of the downstroke starts. I know it sounds strange at first. What I mean by this is that I start the downstroke with a thin point so that when I come back around with the thinner upstroke, I'll be able to connect it easily to that initial thin point. I find that connecting thin strokes to thin strokes is easier than trying to connect thin or thick strokes to their opposites.

Below is an example of the counterclockwise O stroke. I also included a second broken version to show where and how I start and end this stroke so that you can understand my approach.

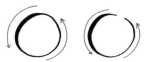

And here's the clockwise O stroke. With this one you'll start with the thin upstroke and end by thinning out the thicker downstroke to connect it to the initial upstroke—the opposite of what you did with the counterclockwise O stroke above. Although it's very common to practice just the counterclockwise O, I wanted to make sure that you practice these also because it's a different feel that doesn't always come naturally. This clockwise O is used for letters like b, k and p.

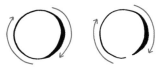

Now that we've gone over how to practice these strokes, practice each of the strokes multiple times on separate sketch paper or in the margins of this page (those rows and rows of strokes I talked about before!).

Forming Letters
USING THE BASIC MODERN BRUSH LETTERING ALPHABET

dare to begin

In this chapter, we're going to go over how to look at a letter, break it down and refine the strokes to create a smooth, beautiful finished product.

I feel that this is a very important step in learning how letters are built because I know how hard it can be to look at someone's lettering and be completely overwhelmed by how they executed it so well. So, let's simplify and try to make the process easier.

We'll be using the Basic Modern Brush Lettering alphabet here since that's an easy alphabet to learn that stays pretty consistent all the way through.

These letters will be round, midsize and simple. They also stay straight along the baseline with no bounce and have no slant. They are also going to be the foundation for the other brush lettering alphabets included in this book.

Let's begin with connecting basic strokes to form letters.

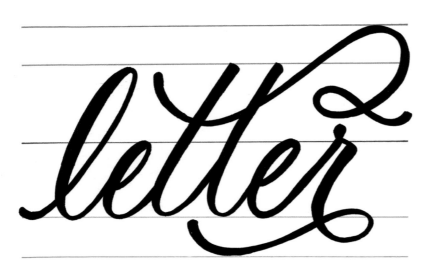

ASCENDER *line*
CAP HEIGHT

X-HEIGHT

BASE *line*
DESCENDER *line*

There is one important thing I want to mention really quickly before starting: Don't be afraid to lift your pen. This is what you should be doing every time you start a new stroke. This is one of the main things that separates modern brush lettering and modern calligraphy from the cursive you may have learned in school. Another difference is the ability to apply more pressure with your brush pen or brush to get thick strokes and apply less pressure to get thin strokes. Take your time and don't hesitate to pause a moment if you need to before moving on to the next stroke.

The first letter I want to break down completely is the lowercase letter a.

$$a = O + U \rightarrow O + U$$

When looking at it, notice that the main shape is round like an O stroke. We also see that the thicker part of the stroke is on the left side, which tells us that this is the counterclockwise O stroke. So, there's our first stroke that we know we'll use.

Next, looking at the other part of the letter, we see that it's curved like a U stroke. And we notice that the thicker part of the stroke is also on the left side. So, now we also know which U stroke we're going to use.

When it comes to refining the shape, take notice of the little things: How the round O stroke gets slightly smaller and narrower at the bottom and how the tail of the U stroke only goes up about halfway. This is exactly what we're going to do now. And this is going to be how we finish up and complete the basic lowercase a.

Looking at letters this way will help make it easier to practice all the letters of the Basic Modern Brush Lettering alphabet. And once you get through that full alphabet, you should be able to completely understand how each letter is constructed, which will make it much easier to learn the other styles included in this book. For example, some of the other styles you'll see and will want to try will have longer shapes or different weights, but you can always remember these basic rules to learn those too. Don't worry about that right now though. Let's take a look at just a few more examples of letter breakdowns.

Here are some more deconstructed lowercase letters: f, k, m, r and z.

$$f = f + b \rightarrow f$$

$$k = l + o + u \rightarrow l + \rho + \cup$$

$$m = I + \cap + \cup \rightarrow I + \cap + \cap$$

$$n = ? + \cup \rightarrow ? + \iota$$

$$z = o + l \rightarrow ? + y$$

When practicing the basic letters, remember to take your time. Always. Most videos we see on social media are sped up due to time restrictions. You may even see some lettering videos that look like they're real-time, but unless the original letterers state that in their caption, always assume they are sped up, even if it's just slightly.

Along with working on smooth strokes and letter structures, I also want to make a quick note about watching the negative space. You'd be surprised how often a letter doesn't look quite right because of the way the inside of the letters and strokes were formed. Like the inside of the letter o or the inside of the looped tail on the letter g, for instance. This isn't the most important thing when you're just getting started, but it's something that's good to keep in mind as you learn. It's definitely one of those things that makes letters more pleasing to look at.

$$g \quad g \quad o \quad o$$

Here is the complete alphabet so you can refer to it and practice all the letters.

a b c d e f g h i
j k l m n o p q r
s t u v w x y z

A B C D E F G H I
J K L M N O P Q
R S T U V W X Y Z

Use a sketchbook or the next page to practice lettering different letters in the alphabet until you get comfortable with them and like your results. Then if you'd like, you can letter the quote "dare to begin" on the next page, just as you see it on the first page of this chapter.

Connecting Letters
TO FORM WORDS

Realize that everything connects to everything else.
Leonardo da Vinci

Connecting letters is one of those things that can be easier for some but a bit more difficult for others. I'm hoping to go over some techniques to show you that no matter how complex it may look, there is always a way.

We'll go over the basic ways to connect letters, and we'll also take a look at some of the more difficult letter connections that I get asked about frequently.

When connecting letters, the easiest connection comes by trying to have a tail that extends from the end of each letter whenever possible before moving on. That way, you can start the next letter right where the other left off without worrying too much about how they'll connect. There are a few connections that are slightly different that some may find a bit more difficult, but don't worry. We'll analyze those too.

BASIC CONNECTIONS

Basic connections are the connections you'll use most often. These are connections that involve just extending the end strokes and tails as mentioned before.

Here are some examples showing a letter, an extension for that letter and how you would connect it to another letter.

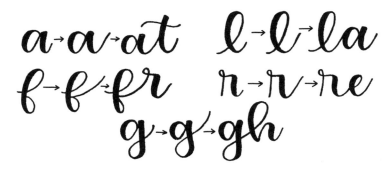

Sometimes you'll come across letters that don't seem to connect easily using the basic connections. When in doubt, try adding a loop. Loops are great and really helpful when you can't think of a better way to go.

Here are some letters that I use loops to connect with. I also included some alternatives that are also possible.

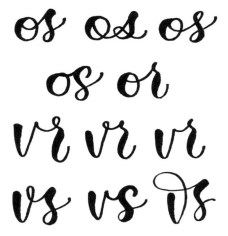

COMPLEX CONNECTIONS

Sometimes there are connections that don't transition easily no matter what. But even with those, we can find a way around the normal rules to make them work.

First, let's look at letters that end higher than where the next letter starts. There aren't many, luckily.

You'll see that loops continue to be very helpful. Also notice how you can finish loops so that they end high or low. And remember to experiment with different styles of letters, just like how I tried a few different styles of s here.

With modern lettering, you have so much more room to try different things. So, never limit yourself. Have fun with letters and all their possibilities.

One last letter I wanted to go over is the letter x. This can be tricky for some. I wanted to show a couple ways you can connect it to other letters.

Now that you've learned some great ways to connect letters, try lettering the quote from the beginning of the chapter on the next page.

Slanted Modern
BRUSH LETTERING

*Elegance
is the only
beauty
that never fades.
Audrey Hepburn*

Using the Basic Modern Brush Lettering alphabet we practiced previously, we're going to learn Slanted Modern Brush Lettering. These letters are going to be a bit more challenging because they need to be consistent when it comes to the slant. The more consistent they are, the more visually pleasing they will be. The normal angle to slant letters ranges from 30 to 45 degrees. I did these examples freehand, like I normally do, so they're going to be around 30 degrees.

These letters are more condensed, taller and elegant. There is no bounce with this lettering style, and they stay along the baseline just like the Basic Modern Brush Lettering alphabet.

BASIC a A m M s S

SLANTED a A m M s S

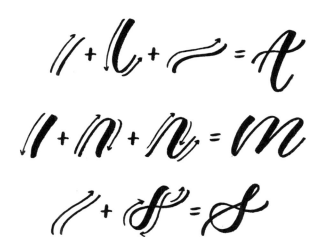

After tracing all the letters directly on the page, always take time to practice even more. You can use the margins of this book or separate sketch paper to practice the letters freehand, or, if you feel you need to go over these letters again to get the structure and angle down, you can take some tracing paper and trace right over the letters again.

The final alphabet, once you've traced all the letters, should look like the example below.

a b c d e f g h i j k l m n o p q r s t u v w x y z

A B C D E F G H I J K L M N O P Q R S T U V W X Y Z

We're going to go over the entire alphabet now, both lowercase and uppercase. Follow the arrows and trace over the letters directly on the page. When breaking down the letters, you'll see how each stroke stays as close to 30 degrees as possible. Make sure not to rush and to take your time keeping each stroke as similar as you can.

LOWERCASE REVIEW

a b c d e f g h i j k l m n o p q r s t u v w x y z

Once you feel confident with lettering this Slanted Modern Brush Lettering alphabet, letter the initial quote using the next page.

UPPERCASE REVIEW

A B C D E F G H I J K L M N O P Q R S T U V W X Y Z

Bouncy Modern
BRUSH LETTERING

There is no fun in perfection.

There is no fun in perfection.

In this chapter we'll be going over Bouncy Modern Brush Lettering, which is not only one of my favorite brush lettering styles, but also one of the most popular forms of brush lettering right now. These letters are going to be challenging at first because they are very exaggerated—at least the way I prefer to do them. There's no right or wrong way to do it. Just the way that feels the most fun to you.

What I mean by that is, you can do bouncy lettering different ways. You can create simple bouncy lettering that stays mainly along the baseline, just pulling downstrokes below the baseline occasionally. I would recommend starting by pulling down the last downstroke of every other letter. Then try every other second letter. This is a great way to start. It helps break you out of your comfort zone of consistent and even brush lettering that we've learned previously.

CAP HEIGHT
X-HEIGHT
BASELINE — *wonderful*

CAP HEIGHT
X-HEIGHT
BASELINE — *wonderful*

You can also try a more exaggerated bouncy brush lettering style that literally bounces on and off the baseline. This is actually the way I normally do it. Notice that when I downstroke, I pull that downstroke really low and then exaggerate the upstrokes by pulling them up really high. When trying this style I recommend experimenting with different variations of letters to exaggerate and also working around, not on, the baseline. Don't use the baseline as a strict guide. It should just give you an idea of where to keep your letters while you're brush lettering.

Here's an example of a complete Bouncy Modern Brush Lettering alphabet that you can reference and practice with.

While you're practicing, let loose. Feel the way the pen moves when you're making exaggerated strokes. Get a rhythm going and don't be afraid of making mistakes. This style is expressive and free.

Also with this style, make sure the arm you're lettering with has enough room to move freely. The more you move your arm with the movements of the strokes, the smoother they'll be. The only exception is if your lettering is very small. If that's the case, you would be moving your wrist more than your arm.

Don't be afraid to vary the sizes of the letters themselves. They don't have to all be the same and consistent. When doing bouncy lettering, many people, myself included, find it very visually pleasing when there are various letter sizes.

When lettering the quote from the beginning of the chapter, you'll be using an exaggerated bounce.

Breaking down the first word, "There," you'll notice the T starts on the baseline along with the h. Then as you finish the h, you're going to drop below the baseline and then bring it back up, just above the baseline to start the e. Following the e, you'll continue to stay above the baseline to start the r, then drop it below the baseline to finish it and bring it back up just above the baseline again for the last e.

I don't have a good reason for the way I choose what letters drop below the baseline or what bounces or even how many letters in a row I'll drop or bounce. I can tell you that I prefer to not follow an exact pattern. I love when it looks more natural, like there's no rhyme or reason to the way the letters end up.

I do try to balance the drops and bounces somewhat though. If there are a couple letters in a row that are moving up from the baseline, I'll make sure to bring the next one down and vice versa, just so it's more or less along the baseline. That way it still looks balanced.

Now use the space below and in the margins to practice more letters and words of your choice, and then you can bounce on over to the next page and letter the quote.

Serif & Sans Serif
MODERN BRUSH
LETTERING

LIVE simply dream BIG

Serif & Sans Serif Modern Brush Lettering are perfect for mixing with other brush lettering styles. They're very complimentary and give an even more modern look with a bit of simplicity.

If you're wondering what the difference between serif and sans serif is, it's that serif-style letters have small decorative lines on the ends of most strokes, and sans (French for "without") don't have them at all.

Serif vs Sans Serif

When lettering in either style, we're going to keep each letter pretty consistent. They'll stay along the baseline and won't vary too much when it comes to the size of each letter. They will be more round than narrow and will also continue to have thicker downstrokes and thinner upstrokes.

You'll notice that just like the Basic Modern Brush Lettering alphabet, I form the letters very similarly. Especially letters like b and p.

Check out the alphabets on the next page and practice them by tracing over each letter. Remember to think of this style as a more simplistic Basic Modern Brush Lettering alphabet when it comes to forming the letters and adding weight to the strokes.

Another thing I do that is unique to my own style is bending or curving the letters slightly when making them. I think they look more fun and friendly that way.

SERIF ALPHABET

A B C D E F G H I J K L M N
O P Q R S T U V W X Y Z

a b c d e f g h i j k l m n
o p q r s t u v w x y z

A B C D E F G H I J K L M N
O P Q R S T U V W X Y Z

a b c d e f g h i j k l m n
o p q r s t u v w x y z

SANS SERIF ALPHABET

A B C D E F G H I J K L M N
O P Q R S T U V W X Y Z

a b c d e f g h i j k l m n
o p q r s t u v w x y z

A B C D E F G H I J K L M N
O P Q R S T U V W X Y Z

a b c d e f g h i j k l m n
o p q r s t u v w x y z

Once you've finished tracing these letters, go ahead and practice more in the extra space on this page and the previous page or on separate sketch paper. Then letter the quote on the next page. I even made sure to include both styles in the quote for more fun.

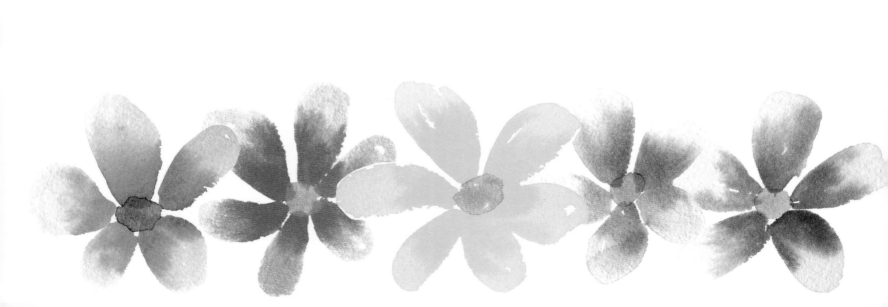

Typewriter-Style
LETTERING

Find joy in the ordinary

Typewriter-Style Lettering is a new love of mine. I love how similar it is to serif-style lettering and that it has a bit of a vintage feel to it.

When practicing this style of lettering, we're going to keep these letters consistent along the baseline and the letters will also be similar in width and height. They will be mainly round, and they will have the same serif characteristics, like the stroke weights, but they will be vertically straight without any curving or bending.

Typewriter
Fabulous

serif
Fabulous

With Typewriter-Style Lettering, a lot of the letters have strokes that start in the middle as opposed to the baseline, which is where the serif and sans serif lettering styles begin.

h→h

m→m

t→t

Another thing that will be a bit different is the way some of the strokes start or end on certain letters like c, f and r. Notice that they have a ball shape where the c and f start and where the r ends.

Here are a few other letters that may be a bit difficult when practicing. Below are letters Q, a and g.

O + ~ = Q

ℓ + c = a

o + ´ ⌣ = g

OPTIONAL: For an even more vintage and styled look, add "ink blobs" to your letters by filling in the corners of letters.

ink blob

ink blob

Now you can practice these letters below by tracing over the alphabets.

Give yourself more time to practice below and then letter the quote on the next page.

abcdefghijklm
nopqrstuvwxyz

abcdefghijklm
nopqrstuvwxyz

ABCDEFGHIJKLM
NOPQRSTUVWXYZ

ABCDEFGHIJKLM
NOPQRSTUVWXYZ

Block-Style
LETTERING

be
FEARLESS
and
BOLD

Block-Style Lettering is a lot of fun. It reminds me of the bubble-style lettering I used to do in junior high on my school binder.

Because this is different from the other styles of lettering in the book, I'm going to break down individual letters so that it's easier to practice.

The one thing I want to mention that might make it easier to understand what to do is that you're going to be using thicker strokes on one side of each letter so that it looks like a shadow. This is one of the reasons why I love doing the Block-Style Lettering with a brush pen.

The letters will also be consistent along the baseline and will be a sans serif style of lettering.

Let's start by tracing around the letters. This is the best way to practice this style when you're first beginning.

First, write out your word with pencil—lightly—making sure the letters have some space in between them.

Then trace around the word with your pencil. Try to keep the outline an even distance from the main letter form so that the block letter will be even all the way around. Also, keep the ends a square shape as opposed to a round shape. We want blocks, not bubbles.

Now using your brush pen, pretend you have a light source shining in from the right-hand side of you and your letters. You want the thicker strokes—the shadows—to be on the left side of the block letter, as if it were an actual 3-D letter.

And then add thin strokes to the rest of the outline.

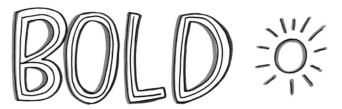

Once you've done that, you can erase the main letter form in the middle. You have now successfully and easily created a block letter.

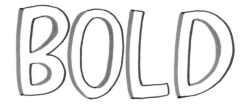

We're going to use that same technique now with more uppercase block letters.

PENCIL LETTER	PENCIL OUTLINE	INK OUTLINE & ADD SHADOWS	FINISHED BLOCK LETTER
M	M	M	M
Q	Q	Q	Q
S	S	S	S

And then with some lowercase block letters.

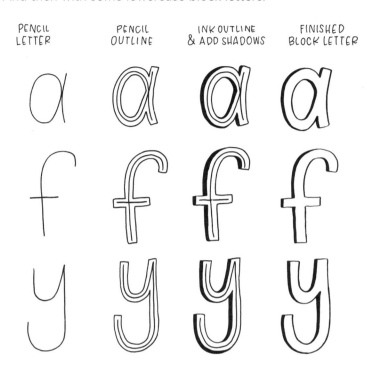

PENCIL LETTER PENCIL OUTLINE INK OUTLINE & ADD SHADOWS FINISHED BLOCK LETTER

That is the way I normally form this style of lettering, but you can also apply the shadow on the opposite side. I wanted to show you a quick example of that too so you have another way to do it.

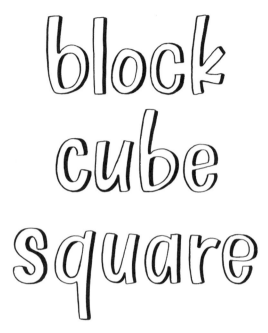

Once you've gotten used to the block letter forms, you'll even be able to do them freehand one day without tracing around the main letter form and without any sketching required. Just keep practicing. Luckily block letters are a lot of fun to practice.

Now, practice these letters some more, and then you can apply these new skills by lettering this chapter's quote on the next page.

Stylistic Modern
BRUSH LETTERING

Great things never came from comfort zones

Stylistic Modern Brush Lettering is different from traditional modern brush lettering styles when it comes to the way weight (thick strokes) is added to letters.

This lettering style is upright and incorporates random thick strokes throughout the words. It's a style that you can definitely add a bounce to. As you're lettering this style, use what you learned in the Bouncy Modern Brush Lettering chapter (page 25) and apply it here too.

I will be showing you one way to letter this style. I recommend, when you're using this style later, switching up which letters and strokes have the thick strokes.

It's completely open to whatever you think looks good.

What I try to do when brush lettering this style is keep everything as random as possible while still giving it some rhythm. If I notice I'm adding too many thick strokes in a row, I'll add a few thin strokes to the next few letters.

Here are examples of lowercase and uppercase letters that you can use when lettering this style.

a b c d e f g
h i j k l m n
o p q r s t u
v w x y z

a b c d e f g
h i j k l m n
o p q r s t u
v w x y z

A B C D E F G H I J
K L M N O P Q R S T
U V W X Y Z

A B C D E F G H I J
K L M N O P Q R S T
U V W X Y Z

Because this is a very unique style, here are a few practice sentences to try before you brush letter the main quote.

endless possibilities

stop and smell the roses

one of a kind

Once you're done practicing these sentences, make sure to practice more in the margins or on separate sketch paper. Then, once you've grown comfortable with this style, letter the quote on the next page.

Have fun with it. If you make a mistake (like adding an extra thick or thin stroke somewhere) go with it. There are no concrete rules to this style of lettering. The only important thing is to enjoy yourself!

Whimsical
BRUSH LETTERING

stop wishing start doing

Whimsical Brush Lettering is a style that is full of large loops and small vowels. It's a style that is very exaggerated and elegant at the same time.

This is a slanted style, and the normal thick and thin rules will apply to the strokes. So, every downstroke will be a thick stroke, and every upstroke will be a thin stroke. It also has the tendency to be pretty bouncy since the letters vary in size, and there will be space in between each letter, which gives each word a long and delicate look.

When it comes to these letters, as I mentioned before, whenever there's a loop on a letter, it's going to be exaggerated as much as possible. Some of these letters, like f, k and l, will feature exaggerated loops.

There will even be some letters that are both small and exaggerated, like b, g and y.

snowflake

frolick

oakleaf

gummy bear

lady bug

good bye

And vowels, a, e, i, o and u, as well as the letter s, are going to be as small as possible to provide contrast.

unequivocally

unquestionably

education

revolutionary

Here are the complete lowercase and uppercase alphabets that you will use when lettering this style.

And here are a few extra practice sentences to try before you brush letter the main quote on the next page. Remember to keep a bounce in the letters and don't be afraid to have letters that are too big or too small. We want the sizes to be as contrasted as possible. Also, keep in mind that the letters should all have the same amount of space in between them. Your connecting strokes will be the only things you elongate, not the letters themselves.

a l w a y s

c h o o s e

j o y

Shine like the stars

always

find your way

choose

it's a beautiful day

joy

Once you feel you've had enough practice with this style, you can brush letter the quote on the next page, or use the space for more practice.

Continue thinking "whimsical" and "elegant" as you brush letter this style.

Mixing LETTERING STYLES

Mixing lettering styles is one of the most creative ways of lettering in my opinion. Learning how to mix them so that they look nice and work well together is a process. So don't worry if it takes some time to get used to. At first, it will more than likely feel very weird to mix different styles, Basic Modern Brush Lettering and Serif Modern Brush Lettering, for example.

I will also go over a few other things for you to consider when mixing styles that I think will help your lettering stand out and hopefully give you a chance to have even more fun with the many types of lettering styles that are available to try.

MIXING LETTERS

When mixing letters, I highly recommend trying different combinations of script lettering along with sans serif or serif print lettering. Don't worry about anything other than playing with different combinations. And don't be afraid to change up the sizes of the letters themselves, as we did with the bouncy lettering. Try alternating between lowercase and uppercase letters for both script and print lettering too.

Here are a couple examples of the ways you can mix up the words Interchange and Alternate.

interchange
INTERCHANGE
INTERCHANGE
iNTERCHANGE

Alternate
alternate
Alternate
alternate

One of the things I love to do is sit down and see how many combinations I can come up with for different words. The longer the word, the better, to be honest. That way, there are even more combinations to come up with.

Also notice how I'll still connect different types of letters, like the script and printed letters. I think at times it can look more fun. There are also times I will skip it all together if I like the way the letters are spaced and how they fit together.

Which brings me to my next topic . . .

NESTING LETTERS

Another way to get letters to look nice and fit well together, especially when mixing different styles, is to "nest" them—that is, fit a smaller letter inside a larger letter.

This will not only improve how everything looks, but it will also give you some new and fun ways to work with letters.

Here are some combinations you can try when lettering.

La Lm oN oR ne
Ve Ve Ve oS Me

These are only a few out of many different combinations you can try—some of my favorites. But don't forget, there are twenty-six letters that you can apply different style combinations to. I bet you can come up with a bunch that I have never even thought of.

SIZE RESTRICTIONS

Another great reason to mix different styles of lettering, other than just having fun, is to fit words together more efficiently when you're creating layouts for quotes. There are times when you only have a certain amount of space, and instead of constantly resizing letters and moving words around, you can make your lettering unique and fun by mixing up the styles of lettering and nesting letters together.

Below is an example of how I worked with the word Letter.

letter

Letter

Letter

In the first example, I used the Basic Modern Brush Lettering style to letter the word—all lowercase, so there was a large loop on the l and the letters had normal spacing in between them.

Then, I tried condensing the word two different ways.

With the first condensed example, I changed the lowercase l to an uppercase sans serif-style L and did the same with the second E. I also changed the two middle ts to lowercase sans serif-style letters.

You can see how just a few changes ended up condensing the word quite a bit. Don't worry if some letters don't completely connect, like the r at the end—that is something that normally happens when mixing different styles.

With the second condensed example, I changed the lowercase l to an uppercase sans serif-style L and did the same with the first and second E. But I decided to keep the two middle ts in the original lowercase Basic Modern Brush Lettering style.

Notice how it's still condensed but not as much as the first example. This is because changing the two middle ts to a sans serif style in the first example took up less space than the two ts in the second example.

Every change will produce different results. Trying different combinations will help you find the best option for whatever project you're working on.

FAVORING LETTERS

Sometimes you don't even need a significant or technical reason to want to change up lettering styles. There were so many times when I was first starting to letter that I would be working on a quote or even just a word, and I would realize that I preferred a certain style of a particular letter more than whatever style I was lettering with at the time.

Because of this, I ended up using certain styles of letters more often than others, and that has became part of my personal style. And that's awesome! Do what feels good to you because that is what's going to give you better results on paper.

Below are some examples of certain sans serif letters that I tend to favor over the modern brush calligraphy script versions—mainly because it's easier for me to quickly switch to the sans serif version than struggle with letters that don't feel natural to me.

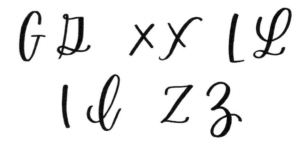

Hopefully these ideas are helpful to you and make the process feel easier as you try your hand at mixing letters. Now it's your turn to mix it up. Practice on the next page or use it to letter the designed quote.

Working
WITH NUMBERS

Numbers are often overlooked when learning how to letter. Mainly because they don't normally appear in quotes and they're not usually included in names, at least that I know of. Even the numbers we add to the end of surnames are roman numerals like II or IV. So, I wanted to take a moment to make sure that you practice your numbers too!

Lettering numbers can come in handy for many things, like when you letter invitations that include dates and also when you letter the addresses onto the envelopes accompanying those invitations.

HAPPY 30TH birth day!

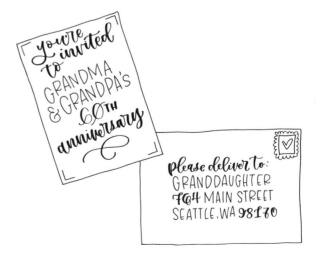

you're invited to GRANDMA & GRANDPA'S 60TH anniversary

please deliver to:
GRANDDAUGHTER
764 MAIN STREET
SEATTLE, WA 98170

You can also letter numbers on things like birthday and anniversary cards to mark the number of years being celebrated.

And we can't forget calendars. You can make your own beautiful DIY calendars for your journal or planner and can even put one up on a wall. With the brush lettering styles you've learned so far, you can easily brush letter the names of the months and days of the week. Now you will also be able to letter all the numbered days too. When it comes to numbers, just like letters, it's easy to find inspiration almost anywhere, including business signs, magazines and packaging. Especially vintage items. Try different styles, different sizes and different weights.

123
123
123

Try adding fancy curls or serifs. Include a small flourish or swash. There are so many creative styles you can come up with to create some very unique numbers.

123
123
123

If you're working on something that requires the numbers to coordinate with a lettering style you're using, try to see what types of details make that lettering style unique, and apply those details to your numbers. For example, are you using a lot of flourishes? Add some flourishes to your numbers wherever you can. Maybe it's all typewriter-style letters. Apply the same style to your numbers too.

HELLO
123

hello
123

hello
123

hello 123

Here are five different styles for each number to help you get those creative juices flowing:

1 1 1 1 1 2 2 2 2 2
3 3 3 3 3 4 4 4 4 4
5 5 5 5 5 6 6 6 6 6
7 7 7 7 7 8 8 8 8 8
9 9 9 9 9 0 0 0 0 0

Have fun with different styles while practicing. Then on the next page, you can create the greeting card sample design as I did it, or come up with your own interpretation!

Fun with
AMPERSANDS

believe in
yourself
&
make it
happen

Ampersands aren't necessarily overlooked, but people can definitely find them intimidating, difficult or just generally not fun. I would like to help change that for you.

I actually used to throw ampersands into anything and everything I was writing and didn't learn until recently that there are actually rules when using them. You're only supposed to use ampersands for things like logos, phrases, names and other proper nouns, such as company names. They're not meant for regular everyday writing. Good thing lettering is mainly just logos, phrases and names!

Cupcakes & Wine

BAKERY + WINERY

I can & I will

MR & MRS BAKER

I'm hoping that in this chapter, by sharing my love of ampersands with you, you'll fall in love with them too. And not just as pretty symbols you find printed on notebooks or shirts but also fun brush lettering subjects that are as enjoyable to make as they are beautiful. All the different styles of intertwining strokes and additional flourishing that you can add to ampersands can be so much fun to experiment with once you learn different ways to do them. And if you're worried that we haven't gone over flourishing yet, don't be—we'll be going over flourishing in full very soon.

You will probably notice that most ampersands are shaped just like an uppercase script E or backward 3 with flourishing added to it. And you'll notice others are shaped just like a backward, uppercase script S, usually with larger loops at the top compared to a regular S. These ampersands in particular are some of my favorite styles.

Here are a couple simple ampersands that are broken down so it's easier to see exactly what we're doing. Most of them will start out this way, so knowing how to create these basic forms should help you better understand how to do the rest of the styles that have added flourishes and are sometimes slightly reshaped.

There will always be some ampersands that are easier to create than others. And you may end up sticking with just those. But don't forget to try other styles. You might even end up altering some while practicing and find a new style that you like even more.

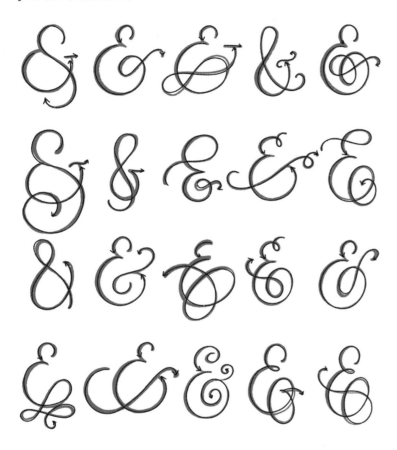

Now take some time to practice these other ampersands. And as with lettering, you will apply pressure for the downstrokes and apply less pressure for the upstrokes. Follow the arrows and trace these ampersands right on the page.

Here's how they should look once you've traced them.

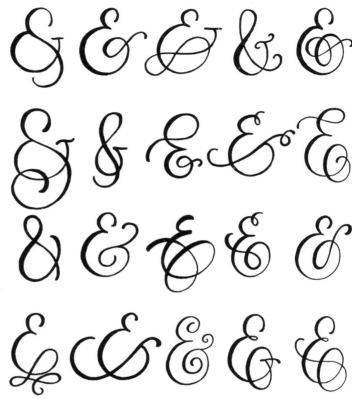

Use the margins or sketch paper to practice different styles that you like. Then pick your favorite ampersand and hop on over to letter the quote on the next page, substituting your favorite style in place of mine.

Flourishing & Ligatures 101

ADDING ELEGANCE & GRACE

In this section you'll be learning how to create beautiful flourishes and simple but impressive ligatures that you can add to your brush lettering for any and every occasion. Creating flourishes and ligatures seems a lot more complex than it actually is because you don't usually get to see how and why they're created, just the finished product. To help, I have broken down these processes as much as possible so that they're easier to understand and, in turn, easier to learn.

You'll first be learning how to make basic flourishes before exploring more complex styles that will not only look amazing but will likely also impress those you end up sharing your designs with. You'll learn how to add flourishes and ligatures directly to your letters, as well as how to add flourishes as embellishments around your words or quotes to complete the overall designs.

As always, take your time. Practice as much as possible in the extra spaces in the book. Know that at the end of this section, you will enjoy adding flourishes to anything and everything with ease.

Basic
FLOURISHES

keep it simple

I think of flourishes as being the cherry on top when it comes to lettering. They can give a lettering design more character and can also fill in spaces when needed. They can be elegant, sophisticated and fun depending on how you use them.

While we go over these five basic flourishes, I want you to concentrate on form. Don't worry about thin or thick strokes or where to put them. Don't worry about anything other than learning how to get nice smooth movements.

Learning these basic flourishes will be the foundational step that prepares you for the intermediate flourishes that are incorporated into the lettering designs in the next couple chapters.

When it comes to flourishes, I don't feel it's my place to tell you whether to go slow or not, because it really depends on the person. So, I will recommend you practice these flourishes two different ways. First try each of the flourishes slow, and then try them fast. Keep trying them over and over again and see what feels more natural to you and what gives you the best results.

One thing I do notice when it comes to my own flourishing is that I'll tend to slow down when I have a flourish in mind for a particular space. That space may be very restricted, so I'll go slow to make sure I'm careful and that it turns out exactly the way that I had it planned. Other times I'll use faster flourishes for freehand lettering when I'd like to get a very particular spontaneous and expressive look—usually when space isn't a concern.

The way I do it may work for you, but if it doesn't, don't go against what feels natural. Do what you need to do in order to create the most beautiful flourishes possible.

S FLOURISH

The first flourish I want to go over is the S flourish. Trace the different variations below. Notice how when I change direction on these, the weights change also. This happens because I continue to follow the rule of light pressure for upstrokes and heavier pressure for downstrokes.

For some fun, you can add spirals to each end, and you can also see how different they look when you vary the size on one end and not the other.

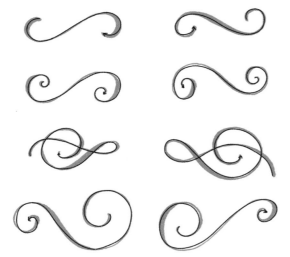

SINGLE LOOP FLOURISH

The next flourish is a single loop flourish. With these you'll want to be very careful when creating the loops so that they are smooth and round. Making the loops too fast will cause jerky movements, resulting in flourishes that are not as nice to look at.

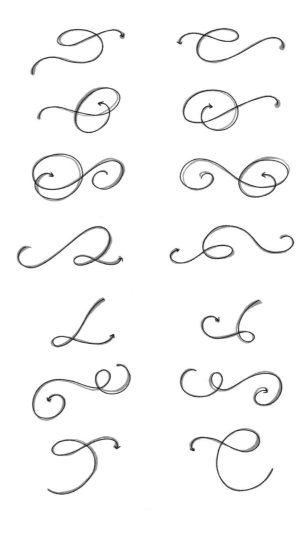

DOUBLE LOOP FLOURISH

Now let's try a double loop flourish. We're going to form it the same way as the single loop flourishes, except that we're just going to add one more loop to each one.

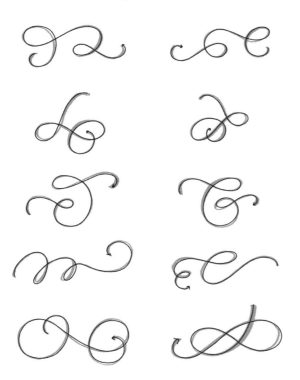

I've also added a couple examples that include ends that look like hearts. These are not only adorable, but they are also fun to make.

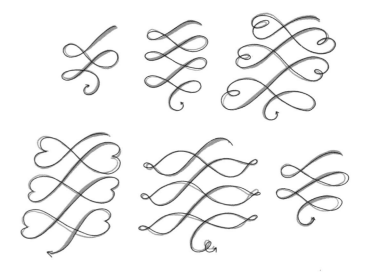

E FLOURISH

This is one that resembles a script style uppercase E or 3.

These are pretty simple since we already learned how to letter the number 3 and the letter E.

You'll notice that to create different flourishes out of the basic shape, all I did was make the center loop larger on one and add curls to the end of another.

FIGURE 8 FLOURISH

And now we'll practice a flourish that resembles a figure 8.

The figure 8 flourish is one of the most popular flourishes. To form it, you want to create lines that are as parallel as possible and loops that are as smooth as possible on each end. Having the same space in between each parallel line and making each parallel line the same weight, whether they're thick or thin strokes, will give it a nice elegant look.

Always remember that some of the smallest and easiest changes to flourishes can create some beautiful and unique results.

Once you've practiced these flourishes, try more on the next page, or use it to re-create my sample quote. It features a single loop flourish.

Intermediate
FLOURISHES

happiness looks gorgeous on you

Intermediate flourishes don't have to mean difficult flourishes. I'm going to be showing you some ways to add to what you've already learned in the previous chapter in order to create even more gorgeous-looking flourishes.

These flourishes, once they're broken down, will be less intimidating and even more fun to make once you see how they're built.

Let's start with a simple add-on technique that connects two different basic flourishes that we learned in the last chapter to produce a larger and more complex-looking flourish.

Here are a few different examples to try.

This first one is an S flourish with an added single loop flourish. You'll start with an S flourish and then add the single loop flourish just below it for a unique and stylish embellishment.

This one is an E flourish and two S flourishes. You will start with an E flourish, making a larger loop in the center. Then on each end you will add an S flourish, making one larger than the other. This is a great flourish to add to the bottom and/or top of quotes you'll be lettering later on.

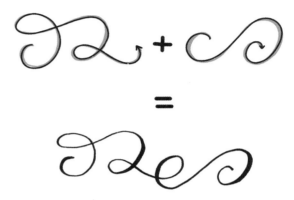

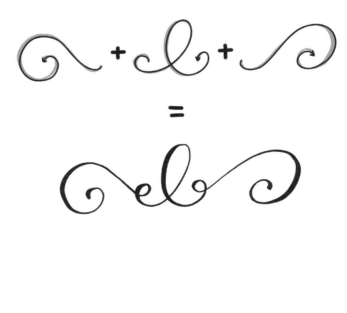

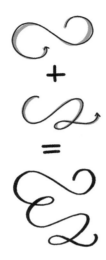

This second one is a figure 8 flourish with an E flourish. With this one, you'll be creating a figure 8 flourish and ending with the E flourish for a simple yet elegant look.

And this last one is a double loop flourish with two S flourishes on each side. You'll start with the double loop flourish and add on the S flourish to the right-hand side and to the left-hand side, continuing to keep it as level as possible with the double loop flourish in the center.

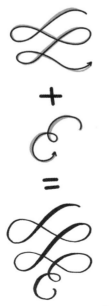

Now you know some of my secrets for creating flourishes that look so elaborate and intricate.

Adding these around your lettering can definitely give it a finished and elegant look, especially if you feel like it's incomplete.

Now let's try some flourishes that include a point to add some interest and variety.

This first flourish is the simplest pointed flourish. It is similar to the E flourish but will have a point in the center instead of a loop.

This one will start just like the one above, but we'll be adding a single loop flourish on the end.

This one is a slightly more complex flourish at first glance, but let's break it down. You'll start with a single loop flourish and add another single loop flourish but connect it with a point. Even though it looks like there's a pointed E flourish involved, it's actually just two single loop flourishes connected together.

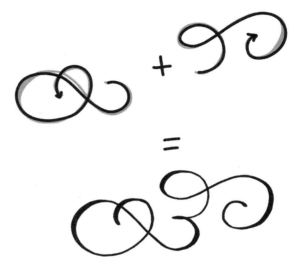

Are you feeling more confident about flourishes? I hope so. They take a lot of time to get the hang of. But it's always rewarding to see the amazing results.

Take time to practice some of your favorite flourishes that you learned in this chapter. You can even practice all of them to see if you prefer some over others.

Flourishes are one of those things that you will always be able to practice and continue to improve on. Don't be afraid of completely changing them or adding even more to them.

Once you're finished practicing, head over to the next page and letter the quote with a gorgeous flourish added to it.

Adding Flourishes
TO LETTERS & WORDS

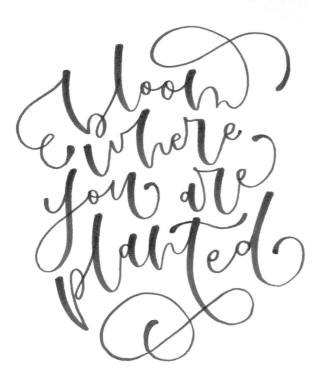

Adding flourishes to letters can give them so much more appeal and charm! Along with the flourishes we've learned previously that can stand alone, these flourishes also offer a great finishing touch.

I will be going over ways to add flourishes to script letters as well as printed letters in this chapter. You don't even have to learn new flourishes. We're going to use the flourishes from the previous chapters and apply them to these letters. I'll even show you a technique that doesn't get used much but that I have received a lot of compliments on. It's a more unique way of adding flourishes.

ADDING FLOURISHES TO SCRIPT LETTERS

When adding flourishes to script letters, you want the flourishes to have very smooth transitions. To achieve that, we'll be adding our flourishes to the strokes at either the beginnings or ends of letters.

If you need to, pause before starting the flourish. It's sometimes easier to create the flourishes that way. The longer the strokes, the less smooth they'll be.

magnolia → magnolia

gladiolus → gladiolus

ranunculus → ranunculus

hyacinth

hyacinth

hyacinth

I also wanted to show a few examples of flourishing parts of a letter, like the crossbar of the lowercase t and uppercase A and H.

Usually you'll be using S flourishes to create crossbar flourishes, but just like other flourishes, there is always room to be creative and add more onto them, which was demonstrated in the last chapter. Go ahead and try these examples below.

With crossbar flourishes, the main thing to look out for is how they interact with other letters. Depending on your style of lettering, you may like flourishes that overlap other letters, but if that's not the case, make sure you keep in mind how they can go around letters that are next to them.

ADDING FLOURISHES TO SERIF & SANS SERIF PRINT LETTERS

I think that adding flourishes to traditional letter styles, like serif and sans serif, is slightly easier than adding them to script lettering because you don't have to make sure they flow as smoothly.

When you add flourishes to serif or sans serif letters, you want to apply them to places that would makes sense if you were to extend that stroke.

For example, it would make sense to add a flourish to the ending on an uppercase R but not necessarily the bottom of a uppercase T. If that were to happen, it might get mistaken for an uppercase J instead.

Some great examples of adding flourishes to serif and sans serif letters appear below.

BONUS ADDING FLOURISHES IN A UNIQUE WAY

Here's a bonus technique for adding flourishes. With this technique, I add flourishes to brush lettered words using a fine tip pen. I find that ball point pens work the best because they tend to glide easier when creating flourishes, resulting in an extremely elegant and delicate look.

First use your brush pen to letter the desired word.

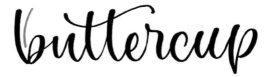

Then take your fine tip pen and choose two different letters to start the flourishes. One will be a flourish placed above the word and one will be placed below.

For this example, I used the first letter to keep things simple.

Take your fine tip pen and start at the bottom of the first letter, creating a flourish by starting right next to it, as shown in the example below. It will be parallel to the letter next to it.

Then create some large figure 8 flourishes going above the word. You'll want to make sure to use your arm and shoulder for these, not just your wrist. You want large and smooth movements.

Just like before, create some large figure 8 flourishes under the word.

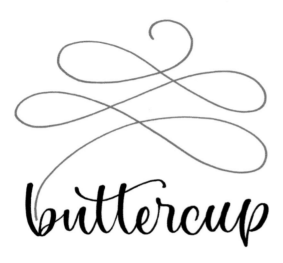

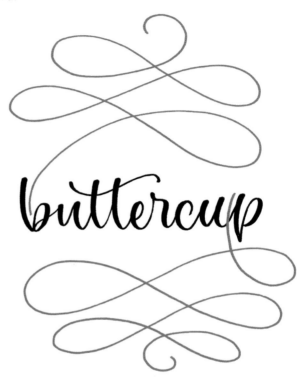

Then do the same with the other letter but starting from the top and moving down.

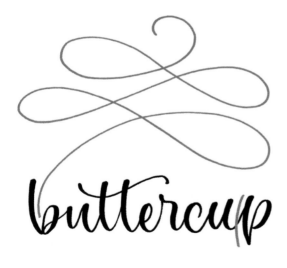

Applying these flourishes to letters is a great technique that will help prepare you for lettering with ligatures, which you'll learn in the next chapter.

Once you've gotten comfortable practicing flourishes on your letters, then you can go to the next page to apply a few of these new flourish techniques to the quote shown at the beginning of the chapter.

Connecting Letters
USING LIGATURES

Connecting letters using ligatures is so much fun! This is something I did a lot early on when I first started lettering, and I still continue to do today. Sometimes I use them without even thinking because a few have become such a normal part of lettering for me.

Ligatures are strokes that connect two or more letters, turning them into one connected, single character. With brush lettering, the opportunities for creativity are endless because of the way letters are formed in modern calligraphy.

I will be going over some of my favorite ligatures that you can use in your lettering.

Some very easy examples are tt, th and tr.

With the first pair of letters, tt, you will be connecting them with a crossbar that extends all the way across both letters. With the other two pairs of letters, you'll be using the crossbar of the t to start the second letter. These are ligatures that I use very often—the type that I do naturally now whenever I letter.

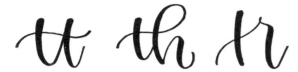

Other ways you can add ligatures include using one letter to finish or start another letter that is below it and part of another word. Some examples of those are extending a letter like g, h, n and r to cross a t.

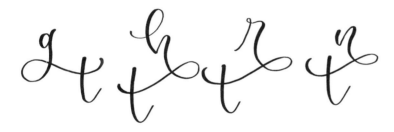

Or using those same letters to connect to the beginning of an h below it, as shown in the examples below.

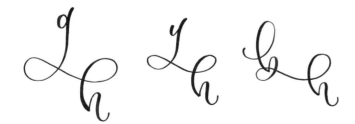

Ligatures make lettering so much more creative—especially when you apply flourishes from one letter to connect to another.

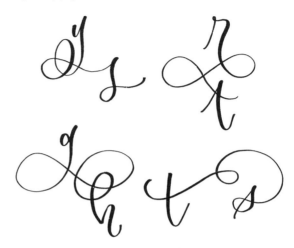

Here are a few more examples of some short, completed phrases so you can see how ligatures work together with other words.

Practice these ligatures a bit more and try to think of other letters that you could connect this way. Then jump on over to the next page to brush letter the quote.

Adding Flourishes
AS EMBELLISHMENTS

This last flourishing technique is all about creative ways to apply different flourishes around your lettering in an aesthetically pleasing way. We're going to go over a few different ways to add flourishes around your lettering and create a unique and beautiful quote illustration.

Sometimes you'll look at lettering and think to yourself that there's got to be something more you can do to make it a more finished piece of art. And you are absolutely correct! Here are some examples of different ways you can do that.

ADDING FLOURISHES TO THE TOP & BOTTOM

With this technique, you'll use an elongated flourish or a couple smaller, mirrored flourishes to frame just the top and bottom of your quote.

ADDING FLOURISHES TO THE CORNERS

For this technique, you'll add small flourishes to the corners of your quote. These will be smaller and applied to either two or four corners of your quote.

ADDING FLOURISHES AROUND AS A FRAME OR OUTLINE

Here you can create a frame of flourishes using similar flourishes that mirror each other and give a clear shape like a square or even a rectangle or circle. The key here is to keep them somewhat simple and similar, so the shape is well defined.

The other style you can create here is the outline of flourishes where the flourishes are random and fit around the quote with the main curves of the flourishes fitting around the curves of the letters. You'll also use smaller parts of the flourishes to fit into smaller areas around the quote. Once that is done, you can add more simplified curved lines around the flourishes for an even more decorated look.

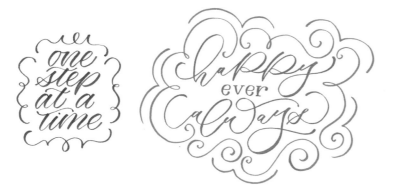

ADDING FLOURISHES AS ILLUSTRATIVE EMBELLISHMENTS

And for the last technique, these are a couple ways you can use flourishes to create small flowers and butterflies around your quote.

Using the same techniques you've learned before, you'll create each stroke for each flower and butterfly by applying pressure to downstrokes and lighter pressure for upstrokes. You can trace these for practice.

Now you'll be using two of these techniques to create your quote.

STEP ONE

Using the Bouncy Modern Brush Lettering style, plan out your quote by lightly sketching the words "Enjoy," "little things," and "life" first with pencil. Make sure everything is centered and evenly spaced. And then add the words "THE" and "IN" using a sans serif lettering style.

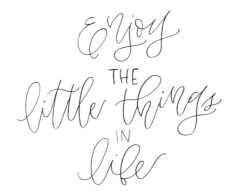

STEP TWO

Once that's done, you'll want to think where you want your flourishes. Since you already know where these will be, you can lightly sketch your flourish embellishments around your quote.

First add the top two flourishes. You'll want to make sure they mirror each other, and also that you have enough room in the center for the flower and leaves flourish. Then turn your book upside down and do the same for the bottom flourishes.

Now you can add the flower and leaves flourish in the center of your first set of flourishes. When doing these, it may be easier to still turn your book upside down to create the bottom flower and leaves.

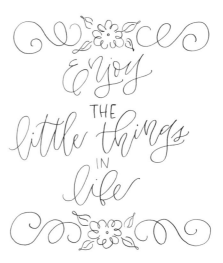

STEP THREE

Now it's time to finalize the quote by going over it with a brush pen and erasing any leftover pencil marks.

I also wanted to show the directions that I used for the flourishes so that it's easier when you do them with your brush pen.

TIP: To make things easier later on when you're erasing pencil marks, use a kneaded eraser to lift off some pencil so you have just a very light sketch before going in with the brush pen.

Now that we've gone over these steps, let's create the quote on the next page. Feel free to practice as much as you'd like first!

SECTION *three*

Letter Effects
WITH BRUSH PENS
& GEL PENS

In this section you'll be learning some fun and creative effects that will add flair to your brush lettering. These will not only be in easy-to-follow, step-by-step formats, but supply lists will also be included in the beginning of each chapter to give you a heads-up about what you'll need before starting.

Some of the techniques you'll be learning here include blending with brush pens and gel pens to create smooth and flawless transitions. You'll also get tips along the way for how to make the process as easy as possible. And you'll learn another very popular style—galaxy lettering—to create your own stellar work of art.

Also included are some of my other favorite types of lettering effects, such as Positive and Negative Lettering. These techniques will bring new life to your lettering and usually look much more intricate and difficult than they actually are.

While going through these chapters, don't forget to continue taking your time while learning these techniques and enjoying the process. You are going to love the results!

Three Ways to Blend
WITH BRUSH PENS

Now that we've learned the basics of brush lettering styles, we're going to get into some fun blending techniques. Blending is one of the most popular techniques that letterers use, and once you get the hang of it, it will not only be fun but easy too.

The quote you see here is a combination of three different techniques that we'll be going over.

As mentioned at the beginning of the book, I recommend using water-based brush pens for blending, as you'll get the best results.

SUPPLIES TO GRAB

- 2 large brush pens, 1 lighter color and 1 dark color

- Blender pen

- Watercolor brush, size 00, 000, 1 or 2

- Small jar or cup of water

- Napkin or paper towel

- Scratch paper (as smooth as possible so you don't fray your brush pens)

STEP ONE

With each of these techniques, you'll start by lettering the word or quote with the base color. This will always be the lightest color, and in this particular example, I used a pink brush pen.

Refer to the lowercase Basic Modern Brush Lettering alphabet on page 17 for the words "make," "your" and "own." And refer to the uppercase Sans Serif Modern Brush Lettering alphabet on page 31 for the word "MAGIC."

make your own MAGIC

STEP TWO

Then grab the second color—in this example, blue—and go over the areas that you'd like to appear darker. I went ahead and chose different areas for each technique to give you some ideas.

make your own, MAGIC

When coloring over the initial lettering, don't worry about how neat or messy it is. Once you start blending, you can fix any little imperfections.

Now we'll go over each technique individually.

STEP THREE—TECHNIQUE ONE

2 Brush Pens

Take the pink brush pen and go over just the initial pink section of the first letter. We'll do one letter at time so that the blending will be easier. Going over the initial color again prepares it for blending since it most likely dried out while coloring the rest of the letters.

Then take that same pink brush pen and "pull" the blue color just slightly into the pink section. You don't need much. A little will go a long way. Just begin at the top of the letter where the blue starts and move the brush pen down to just where the pink starts. Once you're there, wipe the brush pen off on some scratch paper to "clean" it and start blending little by little while continuing to clean the brush pen constantly so that it doesn't become all one color.

make

TIP: Right after you pull some of the blue down the first time, instead of continuing to blend by using downstrokes, try blending by only pulling the pink up, using upstrokes, so that you don't oversaturate with the blue. Finish each letter for "make" the same way.

STEP THREE—TECHNIQUE TWO

2 Brush Pens, 1 Small Watercolor Brush

When using the watercolor brush, start by lightly wetting the blue section in the middle of the first letter y. You can even do it stroke by stroke so that you don't have to worry about the water drying while you're doing the first part of that letter.

Then lightly wet the top pink section and blend with the blue. Do the same with the bottom pink section. Be sure to use as little water as possible—just enough to move the color around. And as with the brush pens, continuously rinse off your brush to clean it so that you don't end up turning the letters all one color.

Do this for each letter of "your own."

STEP THREE—TECHNIQUE THREE

2 Brush Pens, 1 Blender Pen

Taking your blender pen, use it to go over the pink sections of the M and then go over the blue sections. Now right in the middle, blend the two colors together. As with the other two techniques, continuously clean the blender pen by wiping it off on a scratch piece of paper.

You'll notice this gives a slightly different look than the first technique, because instead of adding more color, you're removing some of the color with the blender pen. Luckily it still looks nice and gives the lighter and brighter area at the center of the letters an almost shiny effect.

Continue to do this process for each of the letters in "MAGIC."

Once you've completed all three techniques, your final quote should look like this.

Also, keep in mind that depending on what paper you end up using, there's usually a chance of it "piling," which means the paper gets worn down to the point that the fibers build up and have to be removed from your brush pen and paper. This happens often whenever you blend with any brush pens because of the back-and-forth motion of blending coupled with the moisture of the ink. To minimize this, you can try using a high-quality paper, like specialty marker paper.

On the next page, you can create the quote "make your own MAGIC," using all the blending techniques like I did, or you can choose your favorite blending technique from the three you just learned and use that one.

Blending with
GEL PENS

I love blending with gel pens, especially the neon variety. I get all the "good vibes" from them, making it a great style to letter this phrase!

I used Sakura Gelly Roll Moonlight Pens to create the example in this chapter. These gel pens are great because, while their ink is still wet, they blend very easily. You can also use a similar type of gel pen, but keep in mind that not all gel pens blend easily.

SUPPLIES TO GRAB

- Large brush pen, any light neutral color (light tan, light peach or light pink)

- Gel pens (like Sakura Gelly Roll Moonlight Pens)

STEP ONE

Take your light-colored neutral brush pen and letter the quote. I'm using a light tan brush pen in this example. This will help guide you when you start adding the main colors.

Refer to the uppercase Sans Serif Modern Brush Lettering alphabet on page 31 for the word "GOOD" and the lowercase Basic Modern Brush Lettering alphabet on page 17 for the word "vibes."

STEP TWO

Take your pink gel pen and color in the top half of the G.

STEP THREE

Add the blue to the bottom half of the G. It's very important to apply this technique to one letter at a time. That way they blend easier, since the ink will still be wet.

STEP FOUR

As long as the ink for both colors is still wet, you can go ahead and start blending, beginning with one of the pens. If any of the ink dried, just color around the middle of the letter where the two colors meet to re-wet the ink. Then, blend by switching between the two pens and pulling each color into the other. If needed, add more color from the gel pens and continue mixing the two colors together.

Try to use very light pressure when using these pens. Since they are ball point pens, the ink will flow very easily with just a little pressure.

Keep on going until you're happy with your result.

STEP FIVE

Now just continue these steps for the rest of the letters, including the swash at the bottom.

Make sure to go slow once you've started blending and to do just one letter at a time. Use the space below to practice blending, and when you're ready, you can create the whole quote on the next page.

Ombre
LETTERS

give yourself time

When I think of ombre letters, I think of blending but in a particular way. Although I know that ombre could be a blend of different colors, here we're going to concentrate on just one color and how to blend it so that it transitions from light to dark very smoothly.

SUPPLIES TO GRAB

- 2 large brush pens, 1 lighter shade and 1 darker shade of the same color

- Blender pen

STEP ONE

First, letter the entire quote in the Whimsical Brush Lettering style (page 46) using the lighter-colored brush pen. This will not only be a guide but also the color that the darker shade will blend into.

give yourself time

STEP TWO

Next, grab the darker brush pen and color in just the top of the first letter. Working with one letter at a time will help with blending because you don't want the ink of the darker brush pen to dry too much. As long as the ink from the darker color is still fresh, you will have an easier time blending with the blender pen. If you do too many letters at once, there's a greater chance of some drying and not blending as well later on and leaving a very distinct mark where the darker color was applied.

TIP: If your ink dries, just reapply some of the darker color again at the top of each letter, one letter at a time, and continue with step three. You'll end up with darker transitions, but it's doable.

STEP THREE

Now, take your blender pen and pull the darker color down, making sure to blend the entire time. Start around the middle or bottom of the darker color so you don't pull down too much color; that could overwhelm the lighter color. Also take your time and make sure to move the blender pen up and down softly, so the paper doesn't wear down or tear. Blending all the way down each letter will provide the best results.

Remember that, depending on what paper you end up using, there's usually a chance of it "piling," which means the paper gets worn down to the point that the fibers build up and have to be removed from your brush pen and paper. To minimize this, you can try using a high-quality paper, like specialty marker paper.

If you notice that your lighter color is becoming too saturated with the darker color, you can clean off your blender pen regularly by wiping off the tip on a smooth piece of paper until the color is completely gone.

You don't need to worry if the initial lighter color dried. This technique is more about having the darker color gradually get lighter so that it dissolves into the lighter color.

STEP FOUR

You'll continue to do this for each additional letter until all the blending is complete.

It's time for you to try this technique with the quote on the next page. Take your time and try watching one of your favorite TV shows while you're blending. This technique sometimes takes a while and is the perfect opportunity to catch up on shows that you're behind on.

Galaxy Lettering
WITH BRUSH PENS

There is something so aesthetically pleasing about galaxies. The beautiful colors of nebulas and twinkling stars everywhere. I especially love the fact that you can find pretty much every color in the galaxy. It's absolutely incredible. One of nature's many masterpieces.

Not that it needs to be said, but I've been drawn to galaxies and galaxy art ever since I can remember. Once I got older and got my hands on a good amount of art supplies, I started experimenting with different materials to create galaxies in different ways.

One of the easiest, and one of my favorite, ways to achieve a gorgeous galaxy is with water-based/watercolor brush pens. When using these types of brush pens, you have a lot more control over the color and how it blends compared to using watercolor alone.

SUPPLIES TO GRAB

- 4–5 large brush pens, any color, including at least one very light/pale color (like Tombow Dual Brush Pens, Sakura Koi Coloring Brush Pens, Artist's Loft Watercolor Dual Tip Markers or Ecoline Brush Pens)

- Ink or acrylic paint, opaque white (or a white gel pen)

- Watercolor brush, size 0, 00, 000, 1, 2 or 3 (Using a water brush is an okay option, but it may release too much water when blending.)

- Small jar or cup of water

- Napkin or paper towel

STEP ONE

With your very light/pale brush pen, letter the quote "always be KIND" onto the watercolor paper. I recommend something like a super light gray or neutral color for this. I grabbed a very light peach color. This will serve as a guide for when you're adding the other colors and won't really affect them in a negative way.

Refer to the lowercase Basic Modern Brush Lettering alphabet on page 17 for "always" and "be," and refer to the uppercase Sans Serif Modern Brush Lettering alphabet on page 31 for the word "KIND."

TIP: If you're having a hard time centering your quote, try starting with the middle word first, placing it in the middle of the paper and working around it. (See page 153.)

When I do this kind of color placement, I try to keep the different colors spread out pretty evenly all around. You can follow my pattern if you'd like for an easy guide. Any way you'd like to do it is okay. Galaxies are pretty random and spontaneous.

STEP TWO

This step may feel a bit awkward as you do it, but you'll want to add all the different bright colors randomly within the letters. I used aqua, hot pink, dark blue and purple for this example.

STEP THREE

Time to blend! We're going to get past this awkward stage now. This is where it actually starts looking more like a galaxy.

Dip your watercolor brush into your water and then lightly wet just one color. Lightly wet one of the colors right next to it, making sure not to blend them just yet. You'll also want to make sure not to use too much water. You don't want the water to puddle on the paper.

Now blend those two colors right where they meet. As soon as you take one color and use your watercolor brush to merge it with the other color, they will blend together by bleeding into each other. Doing it this way, color by color, will prevent the colors from becoming muddy. Although that's something that may still happen at times (even with me), this technique will help it happen less frequently.

Another thing I like to do is add clusters. So in some areas, I'll have clusters of tiny stars to give it more interest.

Everything I do here is just dots, but when I vary their size and place them sporadically, it gives a more sparkly effect.

If you're using white ink/paint, you'll do the same but with a very small paint brush: a size 0 or smaller if possible.

Didn't that turn out gorgeous?! I'm somehow always surprised by the results, and you'll get different results every time. You can also add different types of stars. Drawing a very fine x, for instance, will look like a very sparkly star. Try adding a few around for an even more sparkly look.

Now you can try. Practice in the space around the page and then you can create your final galaxy quote on the next page. Take your time and enjoy the process. My favorite part is watching the colors blend together.

STEP FOUR

Adding stars can be intimidating, but it's really simple. Whether you're using a white gel pen or white ink, we're going to use the same technique here.

One thing that I do with my stars may be slightly different than how others do theirs. I like to vary the sizes so they look as random and sparkly as they do in space.

Positive & Negative
LETTERING

One of my most popular lettering posts when I was just beginning to brush letter for my blog was a very simple but unique black and white design. The design was very eye-catching because of the way the lettering contrasted by changing color only where it overlapped the shape behind it.

In this chapter I will be sharing this technique with you and showing you step-by-step instructions for how to achieve this look.

SUPPLIES TO GRAB

- Drawing compass or something else round (around 3 inches [8 cm] in diameter) that you can trace around

- Large brush pen or marker, black

- Pencil (#2 or HB)

- Small brush pen, black

- Gel pen, white (like Uni-Ball Signo or Sakura Gelly Roll)

STEP ONE

Take your compass or round object, like the bottom of a cup, and lightly trace a circle that is around 3 inches (8 cm) in diameter with your pencil. Then color it in with your black brush pen or marker.

STEP TWO

Take your pencil and sketch the words "Radiate Positivity" in the Bouncy Modern Brush Lettering (page 26), using added flourishes. Make sure you keep parts of the words outside the circle for this technique. You should be able to see the pencil, even inside the black circle. Don't worry about it showing. The white gel pen should easily cover it up when you get to that part.

STEP THREE

Now take your smaller black brush pen and letter all the lettering that is outside the circle.

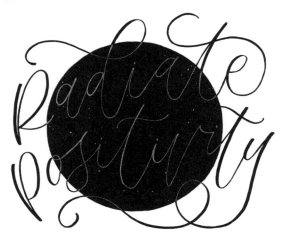

STEP FOUR

Lastly, take your white gel pen and letter over the pencil lettering inside the circle. If needed, when you're done, erase any extra pencil marks that may show.

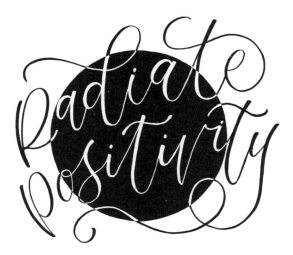

Your turn! Go ahead and practice as much as you'd like. When you're ready, go ahead and try lettering the whole quote using the next page.

Lettering Techniques
WITH WATERCOLOR

If you've been looking forward to learning how to brush letter with watercolor, I'm happy to say you've come to the right place.

I have worked especially hard on this next section to make sure you end up with all the information you need to create gorgeous watercolor brush lettering.

In this section you will learn what some of my favorite supplies are and how to use them to create different effects, like bleeding and blending, with detailed step-by-step instructions. You will also learn which watercolor works best for certain techniques. Plus, tips will be available throughout the chapters to help you achieve the best results.

Watercolor brush lettering is one of my favorite techniques—ever. I hope you have the best time learning this medium. My constant goal throughout this book is to provide you with the best experience with little to no frustration.

Brush Lettering
WITH WATERCOLOR

live in the moment

Brush lettering with watercolor has some of the prettiest effects you'll ever see. And I love the way you can get the most unique results from using different types of watercolor products like pan sets, watercolor tubes and liquid watercolors. My favorite by far for brush lettering is definitely liquid watercolors. When using different colors together, they produce amazing blends and wonderful texture. In this chapter, I will walk you through everything you need to know about supplies and techniques for brush lettering with watercolor, along with the steps to create a sample designed quote. This will be a terrific resource for you to come back to and reference as you practice and build your skills.

WATERCOLOR PAN SETS

Pan sets are one of the most well-known watercolor products. These are the sets you see in stores or online that have round-, rectangular- or square-shaped watercolor "cakes" ready to use in divided trays. The watercolor cakes are completely dry when you get them and have to be "activated" with just a bit of water before using them. I normally spray them with a small spray bottle of water or use a little dropper of water and add 2 to 3 drops to each color, mixing the water in to get them ready for a wet watercolor brush.

They are normally available as student grade or artist grade, just like watercolor brushes and other artist materials. As always, the student grade versions are cheaper and lower quality than the artist grade. But these are great when you're just starting out. They get the job done. The artist grade is usually very pigmented and easier to use when it comes to blending.

Watercolor pan sets often have an attached palette that doubles as a lid to keep everything clean and portable for when you travel. You'll want to use that palette to mix colors whenever needed. Most of the time you don't need to rinse it off, which is nice. I usually wait until my paint dries, and then I'll just close the pan set until the next time I need to use it. It's convenient because all you need is a little water to reactivate the colors again. But if you like to keep a clean palette, it's easy enough to rinse it off whenever you'd like.

WATERCOLOR TUBES

Watercolor tubes are great for not only regular watercolor painting but also for mixing when you need a certain color for a project. Unlike the watercolor pans, which take a lot of effort to transfer only a little color at a time to the palette for mixing, the tubes allow you to quickly apply as much color as you want directly to your palette for mixing. You can also control how pigmented the color will be a bit more than with the pans.

Just like the watercolor pans, you can always find a large variety of colors in both student grade and artist grade.

The only thing I would recommend being careful about is when you initially squeeze the paint out of the tubes. It's normal for it to just pour out. It's also normal for the pigment (the color) and gum arabic (the stuff that binds the pigment together) to separate in the tube. In that case, just shake it or mix it before attempting to squeeze it out onto your palette.

LIQUID WATERCOLORS

Liquid watercolors are one of my favorite things ever. They can be found in bottles that sometimes include a little dropper to make them easier to add to your palette. With watercolor pans and tubes, it's okay to use a very flat palette because those watercolor varieties tend to stay in their place unless you purposely mix them and move them around. But for liquid watercolors, I prefer to use palettes that have deeper wells, like little bowls. I feel they hold that type of watercolor the best so they don't spill everywhere.

I tend to use concentrated liquid watercolors made by Dr. Ph. Martin's, which are actually more of an ink or dye. They're not easy to manipulate once you've applied them to the watercolor paper, but the results are beautiful for brush lettering. They also make Hydrus Fine Art Watercolor Bottles, which more closely resemble regular watercolors, but I prefer the concentrated watercolors more.

When using the concentrated liquid watercolors, just add a couple drops to your palette and add a drop or two of water and mix together. This type of watercolor goes a really long way, so you don't need much. If you need more, just add a couple more drops of the watercolor and water again.

You can also find liquid watercolor that is already diluted and ready to use. A couple brands that are very popular among letterers are Artist's Loft and Royal Talens Ecoline. The Artist's Loft brand is a student-grade version that works really well. And the Royal Talens Ecoline is a bit more costly, but more of an artist grade, it's great quality and worth every penny.

When using a diluted liquid watercolor, just add it directly to your palette and you're ready to go!

WATERCOLOR PAINT BRUSHES

A watercolor paint brush is softer and more flexible than a water brush. This can make the learning process slightly more challenging.

But getting the right brush can definitely help. I recommend getting a round watercolor brush that is small: a size 2 or 3. Try and get one that has synthetic bristles or one that is a synthetic blend. I think synthetic is great for starting out and learning with. They tend to be a bit firmer than something like sable, which is softer and harder to control when lettering. And if possible, I recommend investing in a good-quality brush. It doesn't have to be expensive. A student-grade Winsor & Newton Cotman brush is a great choice compared to something that you can find at a dollar store. I also really enjoy using Princeton Heritage brand watercolor brushes. There are other brands too, but those are the ones I'm most familiar with.

Once you're used to basic watercolor brushes, another great brush to try is a rigger or liner brush. That's something to work up to since they have longer bristles that will take time to get used to.

WATER BRUSHES

I talked a little about water brushes in the beginning of the book (page 11), but to refresh, these are fantastic to use for brush lettering with watercolor. They are really great quality and handle lettering very well since the brush tips are synthetic and firmer than regular watercolor brushes.

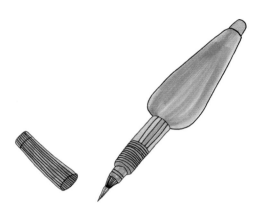

One tip I do want to stress when using water brushes is to make sure you're not squeezing the barrel where the water is held while you're using it. The only time I squeeze mine is to release some water so I can rinse the brush tip off or add water to my paint. When I'm at home, I'll actually just use a jar of water to rinse off the brush tip so I don't use all the water in the barrel.

You may wonder why you should even bother using a water brush if you're not going to use it for travel or outdoor painting, which are its intended uses. It's because the bristles are made in such a way that makes practicing brush lettering so much easier.

Take some time before your next brush lettering session to get used to the feel of the brush if you haven't done so already. Try the strokes below.

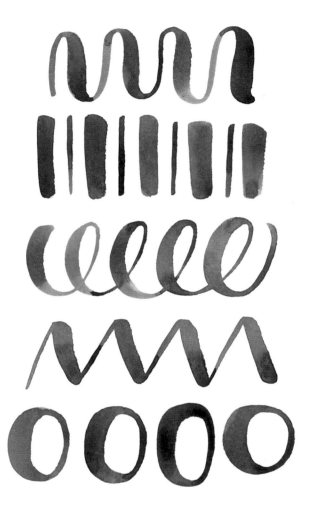

If you love the different shades you can get with just one color, and you're wondering how to achieve a gradient effect, just add a bit of watercolor to your brush and use as much as possible before adding more. The areas in the sample quote that have darker shades are the places where I applied fresh color.

Another thing you may notice are the areas with dark edges. This happens when more water or watercolor is applied near an area that has started to dry. I personally love the way it looks, but if you don't (and that's totally okay), you'll want to check out the chapter on watercolor blending (page 112) to try and avoid that effect.

BRUSH-LETTERED QUOTE

Now let's brush letter the quote shown at the beginning of the chapter using Bouncy Modern Brush Lettering (page 26) and our new watercolor supplies.

SUPPLIES TO GRAB

- Watercolor paint, blue (pan, tube or liquid)
- Watercolor brush, size 2 or 3 (or a water brush, size small to medium)
- Palette
- Small jar or cup of water
- Napkin or paper towel

To prepare, you'll want to get your watercolor ready. If you have a pan set, add a little water to activate it. Since the watercolor cakes in the pan sets are naturally dry, you'll need to add a drop or two of water to each color you're using in order to draw pigment into the brush. If you have watercolor tubes, add some to your palette along with a couple drops of water to dilute it slightly, so that it flows better. And if you have liquid watercolors, add a couple drops to your palette (one with deeper wells) along with a couple drops of water mixed in with it if it's the concentrated type.

STEP ONE

Now that you have your watercolors ready, grab your brush and wet the tip in your jar of water. If your watercolor brush is dripping with water, remove any excess on your paper towel or napkin—just enough so that it's no longer dripping.

Then take your brush and saturate it with some watercolor and brush letter the first word, "live." You'll be brush lettering these words just like you would with a large brush pen, but you'll want to take into consideration how soft the brush tip is.

Something that helps me achieve the best results when brush lettering with a watercolor brush is to keep it at an angle (same as the brush pen), around 30 to 45 degrees, while letting it rest lightly in your hand as you letter. If you were to have the watercolor brush upright (closer to 90 degrees), there's a very high chance you won't have as much control over the brush tip and it will end up making things look less consistent.

TIP: If you notice your watercolor ends up being too light, you can add a bit more paint to the palette to saturate your brush with more color. And if you notice your watercolor ends up being too dark, you can always add a bit more water to lighten things up.

Don't worry if your results give you different shades of color. This is normally a desirable effect when brush lettering with watercolor. It gives it a nice texture and a really great watercolor look.

STEP TWO

Continue brush lettering the rest of your quote. You'll want to remember to center it as well. You can use my example below as a guide for where to place the words.

When you work on other projects later on, you can always lightly sketch the quote first before using the watercolor.

TIP: Make sure to wet your brush whenever it starts to feel dry. If it ends up getting really dry, it won't give good results. Watercolor always needs water to flow nicely, whether you're lettering or painting. If you end up using a water brush, you can just lightly squeeze the barrel to add more water. Just keep in mind that a lot of water brushes will release water excessively, so make sure you remove any excess on your napkin or paper towel.

STEP THREE

Once you've finished your quote, make sure to let it dry. If you need it to dry quickly, you can use a heat tool or hair dryer.

Use the space here to practice lettering with watercolor until you start to get comfortable with the technique. Then, when you're ready, jump on over to the next page and try the quote there. Remember to have fun, relax and not worry about perfection!

Blending with Watercolor
BLEEDING

One of my favorite techniques for brush lettering with watercolor is bleeding. And don't worry. It's not as bad as it sounds. Bleeding is a technique where you let one color flow into another without fully blending them together. For this quote I used the Basic Modern Brush Lettering alphabet (page 17).

SUPPLIES TO GRAB

- Watercolor paint, any 2 colors (Liquid watercolors will give the best results.)

- Watercolor brush, size 2 or 3 (or a water brush, size small or medium)

- Palette

- Small jar or cup of water

- Napkin or paper towel

One thing to keep in mind is that this technique can cause an unwanted effect that creates hard edges when applying watercolor. This happens when you have fresh watercolor that gets added to watercolor that has already started to dry. Some people like this effect and others don't. If you don't, you can make sure the watercolor bleeds softly from one area of the page to another by making sure they both have the same amount of moisture.

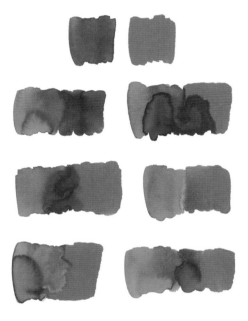

For this technique I love to use liquid watercolors because they're already liquid, and I don't have to worry about overly saturating the color, which is what you'll need to do if you're using a pan set or watercolor tubes.

Before starting, prepare by adding the two different colors of paint to your palette. If it's liquid watercolor, add 2 to 3 drops of color and around 2 drops of water. If you're using a pan set, mix some water into the cakes of color you want to use and put some of each color on your palette, adding more water as necessary. You want it saturated a good amount so everything flows nicely. You'll do the same if you're using watercolor tubes. Add a little to your palette with some water and mix it together. You want a consistency that's similar to coffee or tea.

STEP ONE

Dip your watercolor brush or water brush into your water and lightly touch it to your napkin or paper towel. You want it saturated with water but not so much that it's dripping.

Mix your brush with your first color. Make sure to get a good amount on your brush tip and begin lettering your quote just as you see in the example. You'll be lettering just like you would with a large brush pen but taking the extra flexibility of the brush tip into account, as mentioned in the previous chapter.

STEP TWO

Start with the first letter, l. Using plenty of saturated watercolor, you'll letter this in the practice space below. You'll have to move quickly as you rinse your brush off and grab some of the other color to letter the e next. You'll notice that as soon as the e touches the l, the colors will bleed.

As long as the watercolor is very shiny on the paper, you should have enough water to ensure that the colors bleed together smoothly.

STEP THREE

You'll continue to do this for the rest of the quote. Make sure to keep alternating colors with each letter.

If the watercolor in the previous letter dries and the bleeding effect doesn't happen, you can apply more watercolor and try again.

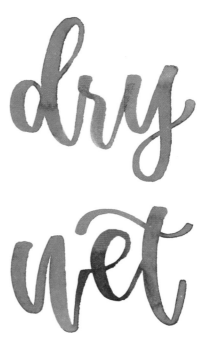

Practice this bleeding technique more in the space below, and then you can complete the quote on the next page and enjoy watching the colors bleed together. This is a technique I love to use often.

Blending with Watercolor
SOFT BLENDING

If you're looking for a softer blend effect for your watercolor brush lettering, this technique is perfect. You'll get a very smooth transition between colors, and the results won't be as spontaneous and unique as with the bleeding technique from the previous chapter. You will be putting in more work to achieve this technique, and it will take more time to finish, but it's definitely worth it to see such beautiful blends of color with the Basic Modern Brush Lettering alphabet (page 17).

SUPPLIES TO GRAB

- Watercolor paint, any 2 complementary colors (A pan set or watercolor tubes will give the best results.)

- Watercolor brush, size 2 or 3 (or a water brush, size small or medium)

- Palette

- Small jar or cup of water

- Napkin or paper towel

Before starting, prepare by adding the two different colors of paint to your palette. If you're using a pan set, mix some water into the cakes of color you want to use and put some of each color on your palette, adding more water as necessary. You want it saturated a good amount so everything flows nicely. You'll do the same if you're using watercolor tubes. If it's liquid watercolor, add 2 to 3 drops of color and around 2 drops of water. Add a little to your palette with some water and mix it together. You want a consistency that's similar to coffee or tea, just as in the previous chapter.

 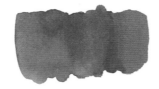

STEP ONE

Dip your watercolor brush or water brush into your water and lightly touch it to your napkin or paper towel. You want it saturated with water but not so much that it's dripping.

Mix your brush with your first color. Make sure to get a good amount on your brush tip and begin lettering your quote. You won't need quite as much as with the bleeding technique—just enough to be able to mix colors together. And you'll continue lettering just like you would with a large brush pen, taking the extra flexibility of the brush tip into account.

Start with the first letter, s. Be sure to use enough water so that there's a nice shine on the paper. Then rinse your brush and grab the next color and start lettering the t. Now you'll mix the colors together using your brush. Use light back and forth strokes to blend the colors together. You want to keep going until it's blended so well that there's no defined transition between the colors.

Your colors will change as they're being blended, so it's a good idea to use colors that mix well together. Make sure to use complementary colors like those shown below.

STEP TWO

You'll continue to do this for the rest of the quote. Make sure to keep alternating colors with each letter.

If the watercolor in the previous letter dries and doesn't blend, you can always apply more watercolor and try again. Make sure to take time and practice. Then you can go ahead and complete the quote on the next page! Try not to rush. Beautiful and smooth transitions take time and patience.

Drop Shadows
ADDING DIMENSION TO YOUR LETTERING

Adding drop shadows is such an excellent technique that can make your brush lettering really stand out and pop off the page. It can also create a great sense of depth and give it more interest.

When first learning about drop shadows, understanding how to place them and how to transition them smoothly around curves can be confusing, so in this section I made sure to go over both of those issues, in addition to sharing different techniques and styles that will make your brush lettering look absolutely fantastic!

Drop shadows are also great for filling space. Especially large spaces that are created when making long drop shadows. The only limit on how you can creatively use that space is your imagination. So as always, have fun, take your time and enjoy the step-by-step instructions and tips along the way.

Using Color
FOR DROP SHADOWS

Drop shadows are such a fun way to get dimension but are often only presented as black or gray. I want to introduce you to colored drop shadows—a fun way to not only add dimension but also additional style.

You can always add colorful drop shadows to colorful lettering, but here we're going to add them to solid black lettering to get the most contrast and ensure they really pop. We'll also go over two different drop shadows: a simple line next to the letters and a full shadow that will be right against the letters.

SUPPLIES TO GRAB

- Large brush pen, black (like a Tombow Dual Brush Pen, Ecoline Brush Pen or Artline Stix Brush Pen)

- Fine tip or bullet tip pen, any color (like the bullet end of the Tombow Dual Brush Pen, Sakura Micron PN or Pentel Sign Pen with a bullet tip)

- Small brush pen, any color (like a Pentel Fude Touch Sign Pen, Sakura Koi Brush Pen or a Zebra Funwari Fude Brush Sign Pen)

STEP ONE

First, letter your quote just as you see it in my example using your large black brush pen. I used a black Tombow Dual Brush Pen.

STEP TWO

While using this technique, we're going to picture our letters as being illuminated by a light source in the upper left-hand corner in order to get the shadows. Imagine that the light is literally shining on the upper left side of the letters. That visual will help you know where to put the shadows—in this case, along the lower right side of the letters.

STEP THREE

For the words "LIVE A" and "LIFE" you're going to use just a line for the drop shadow using any bullet tip or fine tip pen. I used a Pentel Sign Pen with a bullet tip.

The easiest way for me to create this type of drop shadow is by adding a line to the right of each vertical stroke. Then go back and add a line to the bottom of any horizontal stroke. Once you've added all your lines, you'll connect any lines that should intersect at each of the bottom right corners that weren't connected already.

STEP FOUR

For the word "colorful," you're going to do the same but you're going to use a small brush pen. For these drop shadows, I used a Pentel Fude Touch Sign Pen with a brush tip.

Using the same light visualization technique, go along each letter on the right side of the vertical strokes and then the bottom of each horizontal stroke. Finally, connect any strokes that intersect at a corner.

Make sure that wherever you apply the drop shadows with the brush pen that there are no gaps in between the letters and the drop shadows.

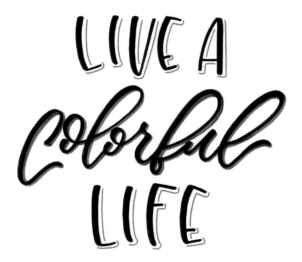

TIPS: I know that curves can be difficult when it comes to drop shadows. Something that I find helps is tapering them as you move around the curve.

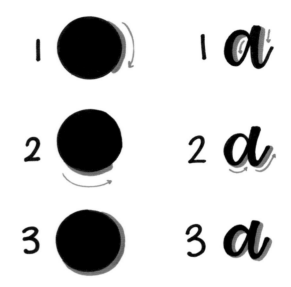

Another way to add drop shadows easily without too much confusion about where they go is to just add them to one side. For example, you would do it the same way as we just went over, but you wouldn't need to add the drop shadows/lines to the bottoms of the letters. You'd basically be applying drop shadows as though the light source were directly to the left.

Now you can try out these drop shadows by lettering the quote using the next page. Feel free to try different colors. The brighter the better so they really stand out! Some favorites of mine are bright pink, bright yellow and bright blue.

Ombre
DROP SHADOWS

Ombre drop shadows are going to be drop shadows that look like they're fading away, just like the ombre letters we tried earlier (page 90). This technique will give the drop shadows a very unique look. The ombre technique is usually just used for the main lettering, so this will definitely catch people's eyes. When creating this look, you want to use a soft color that can fade away easily.

SUPPLIES TO GRAB

- 2 large brush pens, 1 black and 1 light neutral color

- Blender pen

STEP ONE

The first thing we're going to do is letter the quote in solid black. Exactly as you see in the example. The words "focus on the" will be all lowercase Bouncy Modern Brush Lettering (page 26), and the word "GOOD" will be all uppercase serif-style lettering (page 31).

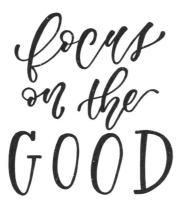

STEP TWO

Then we're going to use a very light neutral color that is complementary to the main color we're using so that there will be just enough contrast to see it against the black lettering. However, I find that blue can sometimes be too similar to black and harder to see.

While imagining the light source, take your light-colored brush pen and apply just the tops of where the drop shadows will be. With the light source on the left in my example, this will be just to the right of each vertical stroke.

STEP THREE

Now take your blender pen and pull some of the color down to finish the rest of the drop shadows, making sure to wrap around the bottoms of the letters.

TIPS: Be careful when using the blender pen because it can blend some of the black into the ombre drop shadows. If you're worried about the main lettering blending into the drop shadows, use a waterproof archival black brush pen like the Faber-Casell Pitt Artist Pen, Zebra Disposable Brush Pen or even a Sharpie (though you won't be able to brush letter with most Sharpies, they do have fabric brush pens and other new brush pens available).

You can also apply the ombre technique that we went over in "Three Ways to Blend with Brush Pens" (page 82).

Now try re-creating the quote using the next page. Other colors that would be great to try are soft yellows, purples, greens and other pastel colors. You can even change the colors of the drop shadows so they alternate with each letter.

Have fun with this technique!

Texture
DROP SHADOWS

Texture is so fun to create and a great contrast to brush lettering. I love the look of a rough texture against smooth brush lettering. It's another wonderfully unique way to create drop shadows. The type of texture we'll be going over in this chapter may look complex, but it's really just a lot of even and consistent scribbling.

SUPPLIES TO GRAB

- Large brush pen, any color (I used a Sakura Koi Brush Pen.)

- Fine tip pen, black (like a Sakura Pigma Micron PN Pen or Tombow MONO Drawing Pen)

- Pencil (#2 or HB)

- Eraser (I prefer to use the Pentel Hi-Polymer Eraser or other white plastic eraser.)

As I mentioned before, the main thing you want to do is keep your scribbles as consistent as possible. There are a few different ways you can scribble (actually there are probably a lot!). I'll show you just a few examples here that I've found to work well.

STEP ONE

We'll be using the first texture example for our drop shadow in the sample quote.

First, take a large brush pen in any color and letter the quote shown below.

be fearlessly authentic

The words "be" and "authentic" will be done using lowercase Typewriter-Style Lettering (page 35), and the word "fearlessly" will be done using Stylistic Modern Brush Lettering (page 42).

STEP TWO

Then, remembering to use the imaginary light source, draw some guidelines with your pencil to show where the drop shadows will be. You can do it just like I did in the example below. I drew diagonal lines in all the same direction on the same side of each stroke. After that, I connected them to complete the drop shadow shape by curving the lines to mirror the original curves of the letters.

This is also the same way I create 3-D letters, especially with block-style letters (page 37).

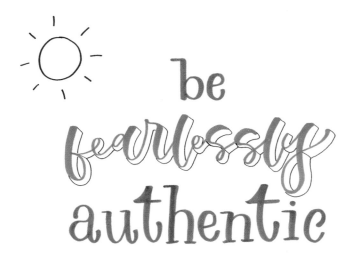

STEP THREE

Now for the fun part. Just scribble away in all the shadow areas. Try to keep it as consistent as possible for a nice clean look.

For an even cleaner look, you can define the border of the drop shadows so they'll keep their shape without looking completely disorganized.

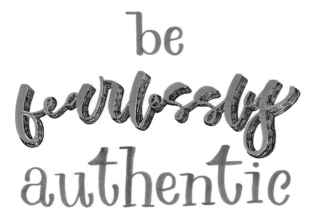

TIP: For an even more fun look, take a white gel pen (or other bright gel pen) and add a line between the drop shadows and letters.

And here are a few more ideas you can try.

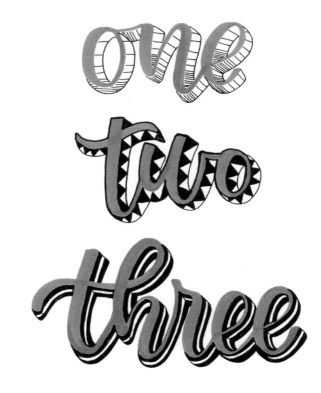

Use the space below to try practicing this technique in a couple styles and sizes. Then, when you're ready, you can take your new scribbling skills and have fun lettering the quote using the next page.

Long DROP SHADOWS

Long drop shadows give such a strong look to lettering. It provides so much dimension and really pops off the paper and grabs your attention. What I love most about long drop shadows is that you can do so much in the space they create. In this chapter, I'll show you how to create a long drop shadow and some different things you can try in the space provided by the shadow.

SUPPLIES TO GRAB

- 2 large brush pens, 1 black and 1 bright color
- Gel pens, white or different bright colors (like the Sakura Gelly Roll Moonlight Pens)
- Pencil (#2 or HB)
- Eraser (I prefer to use the Pentel Hi-Polymer Eraser or other white plastic eraser.)

STEP ONE

First, brush letter the quote that you see in the example. We'll do solid black since the focus will be on the drop shadow.

I used a Sakura Koi Brush Pen and Block-Style Lettering (page 37) for the quote.

STEP TWO

Then we'll use our imaginary light source and create pencil guidelines for the shadow. They will go the same direction as in previous chapters, except now we're going to take these guidelines all the way to the edge of the page. Follow the guidelines shown. Notice how I didn't go through any letters. The guidelines stopped at any letters and again at the edge of the page.

You'll also notice that you don't have to always worry about all the areas inside the letters. You mainly just want to define the very outer edges of the complete word.

STEP THREE

Now, to complete the drop shadow, color in that entire space with a different brush pen, anything other than black since that's what we used for the lettering. For this drop shadow I used a Sakura Koi Brush Pen. Using a bright or light color will help the drop shadow stand out more.

STEP FOUR (OPTIONAL)

Now let's have some fun with all that space it created! Grab your white or bright-colored gel pens and add some elements in the drop shadows.

Some things you can try are filling up the space with . . . space! Create a galaxy look using the technique shown in "Galaxy Lettering with Brush Pens" (page 93), complete with stars.

And even just random patterns like lines, shapes or blended gradients.

You can have so much fun adding to the quote you are lettering. Get creative and play with different effects in the space below.

Try the example quote now on the next page. And remember, adding extra elements to the drop shadow is completely optional.

Or you can draw flower and leaf outlines. They don't even have to be too fancy. You can doodle them like I did in the examples below.

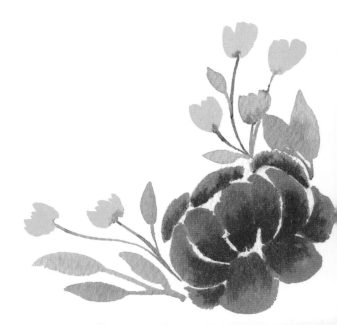

Backgrounds
CREATING DEPTH & BEAUTY

Creating backgrounds is another fantastic way to add more depth to your brush lettering. In this section you'll learn how to make different types of backgrounds, including an elegant ombre background, a fun tie-dye background, an out-of-this-world galaxy background and a beautiful sunset background. These backgrounds are not only perfect for inspirational quotes but also quotes that match the background. For example, quotes about space and galaxies are perfect for the galaxy background, just as quotes about sunsets would be perfect for the sunset background.

Another technique you'll learn involves creating a background by just going around the border. This will end up providing a great torn-paper effect.

All of these techniques continue to include supply lists and step-by-step instructions, along with tips to help you get the best results. Have fun creating these backgrounds and quotes, and make sure you always take advantage of the practice spaces available in each chapter.

These backgrounds will definitely give you some gorgeous works of art that are so colorful and at times, even magical.

Ombre
BACKGROUND

Ombre backgrounds are so gorgeous. One of my most popular pieces ever had a pink ombre background with gold brush lettering.

Here we're going to concentrate more on achieving a nice smooth ombre background with a very freestyle look to it and then we'll letter our quote right on top.

SUPPLIES TO GRAB

- Watercolor paint, any color (I used liquid watercolors, but you can use any kind of watercolor paint.)

- Watercolor brush, size 6, 7 or 8

- Large brush pen, black or purple

- Palette

- Jar or cup of water

- Napkin or paper towel

Before starting, prepare by adding the paint you'll be using to your palette. If it's liquid watercolor, add 2 to 3 drops of color and around 2 drops of water. If you're using a pan set, mix some water into the cakes of color you want to use and put some of each color on your palette, adding more water as necessary. You want it saturated a good amount so everything flows nicely. You'll do the same if you're using watercolor tubes. Add a little to your palette with some water and mix it together. You want a consistency that's similar to coffee or tea, just as in previous chapters.

STEP ONE

Using just water, saturate your watercolor brush. Then go back and forth (left to right) on the paper, starting from the top of the page down to the bottom. Keep some border space around where you're applying the water and make sure to create uneven edges on the sides. This gives the finished piece a more relaxed feel.

If you have different sizes of brushes, the biggest size would work best. I like to use my size 8 watercolor brush, although I have also used a large flat brush for larger areas.

TIP: If you have a hard time seeing the water, you can use tinted water. That could be either "dirty" water you've already used for other watercolor projects or water that you've tinted with just a bit of paint to make it more visible on the paper.

STEP TWO

Now add some paint to your brush and apply it to the top section of the water-saturated paper. Blend that color down by moving your brush back and forth (left to right) about halfway down the page, making sure to have the darkest color at the top and the lightest color at the bottom.

If you end up blending all the way down, just add more color to the top. You want to have a gradient of dark to light moving down the page.

Once you're happy with the results, you can either wait for it to air dry or use a heat tool to dry it. You can even use a hair blow-dryer if you don't have a heat tool available.

STEP THREE

Once it's completely dry, letter the quote in Slanted Modern Brush Lettering (page 23) on top of the background.

If you're worried about centering the quote, you can very lightly sketch it out with pencil first. Make sure the brush pen you're using is dark, and then go over the pencil sketch.

The only thing with using pencil over the watercolor background is that it won't always erase easily. And if it does, it will most likely lift some of the watercolor off the paper, creating light spots. Otherwise, don't worry. Let the words flow naturally.

You can use the space here to practice and get a feel for the technique on a small scale. And when you're ready, you can create this gorgeous ombre technique with the full quote using the next page.

Tie-Dye Effect Background
USING BRUSH PENS

find happiness in rainbows

When I first made this background, I was actually trying to create a colorful galaxy background, but it turned out looking more like tie-dye than a galaxy. I loved the result either way, and I'm thinking you will too.

This style has major '60s and '70s vibes and will be slightly different than the way I originally tried this technique because you're going to be creating a very popular style of tie-dye: the spiral. It's not the easiest to create, but it's so fun and very colorful.

SUPPLIES TO GRAB

- 5 large brush pens, 1 blue and 4 complementary colors (like Tombow Dual Brush Pens, Royal Talens Ecoline Brush Pens and Sakura Koi Brush Pens)

- Watercolor brush, size 6, 7 or 8

- Jar or cup of water

- Napkin or paper towel

- Table salt or small jar of bleach (optional)

STEP ONE

Start by creating a spiral with your brush pens. I recommend using at least a few colors that complement each other. I used pink, yellow, blue and purple to achieve a very colorful rainbow design for this background. Start in the center and work your way out, one color at a time. Leave a bit of white space in between colors, as shown below.

STEP TWO

Next, take your watercolor brush and wet it. Then use it to saturate the first color you used when you started the spiral. Here it's pink. While it's still wet, saturate the next color with your watercolor brush and lightly touch it to the first color so they bleed into each other.

STEP THREE

Continue doing this for each of the other colors, one color at a time. Make sure that when you combine colors to bleed together, they're both saturated with water.

You'll want them to end up all bleeding into each other to achieve the tie-dye effect. The white space between colors in the beginning was intended to give you more control when blending the colors this way.

TIP: If you have a color that you're working with that has dried too quickly, just re-saturate it with water and keep going.

STEP FOUR

Once you're happy with the results, you can let it dry or dry it yourself with a heat tool or blow-dryer. Then you can letter the quote right on top with your blue brush pen.

OPTIONAL EFFECTS

For a different look, splatter some water with your watercolor brush over the tie-dye background once you're done. You can do this by tapping a wet watercolor brush on top of a dry one, or even tapping it on your hand so that the watter spatters.

Use salt in between each of the spirals of colors while they're still saturated with water for more texture. The salt soaks up the water and leaves light spots behind.

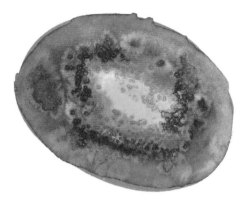

Another thing you can try is using bleach in the same way as the salt. Put a little bleach into a small cup or jar and apply it with a cotton swab in between the spirals of colors while they're still wet to remove the color completely in those exact areas. This can give the background even more of a tie-dye effect.

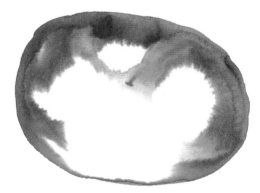

Practice this technique as much as you'd like and then jump on over to create this "far-out" tie-dye technique on the next page.

TIP: Look for inspiration online by searching "tie-dye designs" for more color combination and design ideas.

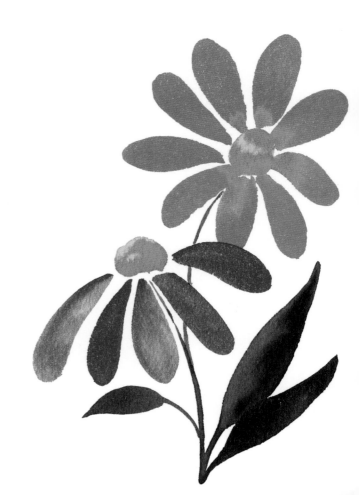

Galaxy Background
USING BRUSH PENS

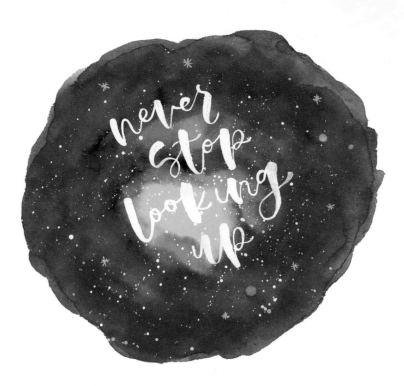

Creating galaxy backgrounds with watercolor produces some very beautiful results. But did you know you can also use water-based brush pens to get a great galaxy background too? Galaxies are hugely popular right now, and this technique is an easy way to make some wonderful ones of your own.

SUPPLIES TO GRAB

- 4 large brush pens, yellow, pink, light blue and dark blue

- Watercolor brush, size 6, 7 or 8

- Watercolor brush, size 2 or 3

- Ink or paint, opaque white (like Dr. Ph. Martin's Bleed Proof White ink, white gouache or white acrylic paint)

- Jar or cup of water

- Napkin or paper towel

- Toothbrush (optional)

STEP ONE

I really enjoy bright and colorful galaxies, so that's what I'll be explaining how to make in this chapter. First, take some of your favorite colors of water-based brush pens and randomly color around the page. For the example I used a bright yellow, light blue and bright pink, which gave me a great variety of colors when they blended together.

STEP TWO

Next, take a black or really dark blue or purple brush pen and go around the edges of the page. This will add to the dark outer space look and give the background a really nice contrast.

STEP THREE

Now take your larger watercolor brush and blend all the colors, using the same technique as in the Galaxy Lettering with Brush Pens chapter (page 93) when we blended the lettering. This will prevent you from ending up with a muddy look. You'll want to wet the colors individually and then blend them with the color next to them. Take your time to get the best results.

STEP FOUR

Once you're happy with the way the colors turned out, you can move to the next step. If you'd like a bit more dimension, feel free to follow the last few steps again and do another layer.

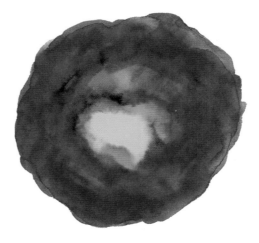

STEP FIVE

Now you can add stars. There are a couple different ways that work well with a large space like this. You can take your time and do each star like we did in "Galaxy Lettering with Brush Pens" (page 93). It will give you the exact results you want, but it can be really time-consuming.

The other way you can do it is by using white ink, or even gouache or acrylic paint. Take a paint brush and saturate it with the white ink or paint—not to where it's dripping though, because you'll have large white water drops on your page if you do it that way. Then take another paint brush, brush pen or even your finger and tap it a few times around your paper to get very tiny clustered stars.

You can then add hand-drawn stars individually with an opaque white gel pen (like a Uni-Ball Signo UM-153 White Gel Pen or Sakura Gelly Roll Pen) to create more interest.

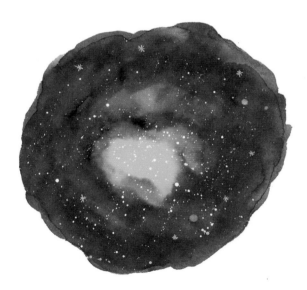

Once you're done, just wait until everything dries. You can dry it yourself with a heat tool or blow-dryer, but for this background in particular, I find the colors are brighter if they air-dry naturally.

OPTIONAL: Use a toothbrush to splatter the white ink or paint. This will give a lot of tiny splatters and also look great. To try this, take your toothbrush and saturate it a bit with white ink or paint, just like you did with the paint brush. Then take your finger or thumb, and while the toothbrush is upside down, run your finger or thumb through the bristles to spatter the paint or ink.

It can be a messy process, but it gives gorgeous results. I like to do it this way to get a bunch of tiny stars, then I take my watercolor brush or gel pen and add larger individual stars for contrast.

STEP SIX

Once the background is completely dry, you can brush letter your quote on top of it using the white ink or paint and your smaller watercolor brush.

Now it's your turn! Practice below on a small scale, then when you're ready, go ahead and create this stellar design on the next page. When you create more later on, try different color combinations for different galaxy looks.

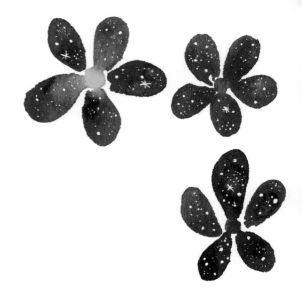
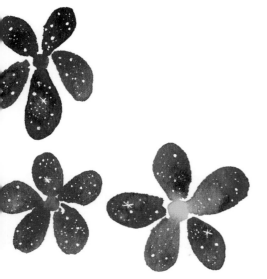

Sunset
BACKGROUND

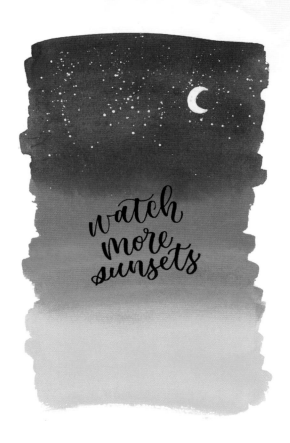

Creating a sunset background is surprisingly easy. The way I'm going to show you how to do it will hopefully eliminate any difficulty so you can enjoy the process of making this background as much as the others. Sunsets can be many different colors—from yellow to red all the way to blue and purple. I've even seen gorgeous pink sunsets. I'll be showing you a very popular color combination for sunsets in this technique.

SUPPLIES TO GRAB

- Watercolor paint, any 3 sunset colors (yellow, red, pink, purple or dark blue)

- Watercolor brush, size 6, 7 or 8

- Palette

- Large brush pen, black

- Jar or cup of water

- Napkin or paper towel

- Ink or paint, opaque white (optional)

Before starting, prepare by adding the three different colors of paint to your palette. I used yellow, pink and purple watercolors. If you don't have those colors, you can try yellow, red and dark blue. If it's liquid watercolor, add 2 to 3 drops of color and around 2 drops of water. If you're using a pan set, mix some water into the cakes of color you want to use and put some of each color on your palette, adding more water as necessary. You want it saturated a good amount so everything flows nicely. You'll do the same if you're using watercolor tubes. Add a little to your palette with some water and mix it together. You want a consistency that's similar to coffee or tea, just as in the previous chapter.

STEP ONE

Picture the area in three equal parts. You can add guidelines lightly with a pencil or just eyeball it.

Starting with your lightest color—in this example, yellow—paint the bottom section. Start toward the bottom and work your way up, stopping where the middle section starts. Make sure to keep the watercolor as saturated as possible so that when you add the next color it will blend easily.

STEP THREE

Now use your purple or dark blue and start toward the very top of the upper section, working your way down toward the pink/red. Once you get to the pink/red, blend the two colors together—just enough to mix them, but not enough to completely change either of the colors.

STEP TWO

Take your pink or red watercolor and start painting the middle section. You'll start at the top of that section and move your way down toward the yellow section. Once you get around the yellow, blend just enough to mix the two colors but not so much that you turn all the yellow to orange.

If you notice it's starting to turn more orange than you'd like, just rinse off your brush and remove the excess water on your napkin or paper towel by touching the tip of the brush to it, then keep blending. Continue rinsing off your brush while you're blending until the pink/red stops oversaturating the yellow.

STEP FOUR (OPTIONAL)

Once you're done, you can use some white ink or paint and add a small crescent moon and stars in the top section of the background for a little added style. And later on, when you're even more comfortable with this technique, you can also add silhouettes of palm trees, people, a beach and even an ocean.

STEP FIVE

Once everything is dry, take your time and letter your quote using Basic Modern Brush Lettering (page 17) in the center of the background with your black brush pen. It doesn't have to be perfectly centered, just close to the example below.

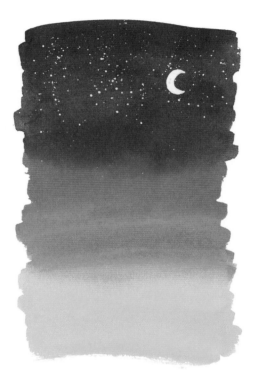

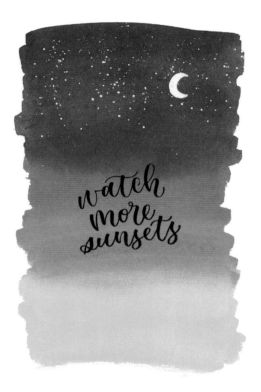

Another popular idea is a desert sunset. You could add some cacti and a full moon. And you can even add a forest with some pine trees and stars up above. I'm just going to add a small crescent moon and some stars to this example to keep it simple.

Your turn! Try out this technique on practice paper and then create your sunset background and quote on the next page. Feel free to try the optional ideas included in step four. Make it your own beautiful design.

Just the Border
USING WATERCOLOR

This is something that is so simple but also such a fun look to frame quotes. With this technique, we're going to apply watercolor to just the border of the quote. The look you're going to get is torn paper on top of a watercolor background. When I first tried this I was quite surprised that something so simple could look so pretty.

SUPPLIES TO GRAB

- Watercolor paint, any 2–3 colors (I used liquid watercolors.)
- Watercolor brush, size 6, 7 or 8
- Watercolor brush, size 2 or 3
- Palette
- Jar or cup of water
- Napkin or paper towel

Normally I would apply this technique to small quotes that I brush letter on trimmed watercolor paper, usually around 4 x 6 inches or 5 x 7 inches (10 x 15 cm or 13 x 18 cm), but since we're practicing here in the book, we're going to use the border I included and apply it that way. You'll do it the same way later on, but on an actual border, when you're working on sheets of watercolor paper.

Before starting, prepare by adding the two or three different colors of paint to your palette. I used blue and purple liquid watercolors here. I tend to use liquid watercolors often because of how easily they blend together. But you can also use a pan set or watercolor tubes. If you're using a pan set, mix some water into the cakes of color you want to use and put some of each color on your palette, adding more water as necessary. You want it saturated a good amount so everything flows nicely. You'll do the same if you're using watercolor tubes. Add a little to your palette with some water and mix it together. If it's liquid watercolor, add 2 to 3 drops of color and around 2 drops of water. You want a consistency that's similar to coffee or tea.

To make sure your colors are saturated enough to blend together in this technique, saturate your brush so that it *almost* drips with the watercolor. If it does drip, just remove the excess water on your napkin or paper towel.

STEP ONE

Start by using your larger watercolor brush to blot color along the edges of the border. Start on one side and work your way around. Keep your blots of color close enough to blend together and switch between your colors to get some nice blending and visual interest. Make sure to rinse your brush when changing colors.

Try to apply the watercolor fast enough so it continues to blend all the way around. But don't stress if it dries while you're doing it. You can always re-saturate any area with a bit of water.

Keep the watercolor marks uneven and spontaneous. That way you'll get the unique look of torn paper.

STEP TWO

Once you've finished painting all the way around, let it dry completely to avoid any smearing, and then choose one of the colors you used for the border to brush letter your quote inside the open space using your smaller watercolor brush, using Modern Stylistic Brush Lettering (page 42).

Using one of the colors you've already used will give it a nice touch of harmony since the colors will match so well together.

OPTIONAL: Try splattering some color around with the same technique used to splatter stars on a galaxy background (page 142). This results in a more stylized look when you use the same colors that appear around the border.

Now try out this technique in the practice space below. The next page is intentionally blank, so you can create your own special watercolor border. Remember to keep the edges jagged and random for the best results. Add the quote and your art is complete!

Composition

HELPING WORDS FLOW TOGETHER

What do you struggle with most? For a lot of people, it's composition. Being able to create a layout that fits all your words nicely together, while at the same time making sure they look balanced and centered, can be a lot of work that's usually full of frustration.

In this section you will learn how to center simple quotes completely freehand using a favorite technique of mine. And you will also learn different ways to fill up shapes and silhouettes with flourishes to create some very unique designs.

And just like the last few sections, these chapters also have supply lists so that you'll know what you need right away. Step-by-step instructions will keep each new technique as easy and simple as possible.

By the end of this section, you'll be able to create layouts for your quotes like a pro!

Centering
MADE EASY

if it was easy everyone would do it

You may have wondered why certain aspects of lettering come so easily to some and not others. Sometimes people are just literally that good. It's rare, but it happens. For the rest of us, sometimes there are techniques that can help.

When doing freehand lettering, I like to try centering the words, but I don't always necessarily want to sketch them out first with a pencil. At that point, you have to worry about erasing all the pencil marks and the potential for pencil marks showing through the finished brush lettering. Especially if you're using light colors.

I like to look at the quote I'm about to letter and think of how I want to lay out the words. Whenever I start to letter it, I take the longest word or words and center them on the page first. This helps guide me when it comes to adding the other words.

everyone

Then I add the other words to the top and/or bottom of the initial word(s) I already placed on the page and keep going until I'm done, making sure I keep all the words in order.

was easy everyone would

One thing that I find very helpful is counting letters. For example, if I am ready to add a word on top of the main focal word but am unsure how it will fit, I would count the letters in both words.

So, in this case, the main focal word, "everyone," has 8 letters and the words "was easy" above it have a total of 7 letters.

Knowing that, I will center the middle of "everyone" with the "e" in the word "easy" right above it. But make sure to remember to take into account any spaces that could throw off the centering.

Also, don't forget to take into account different sizes of letters. For example, the letter i will take up less room than the letter m.

Don't be afraid to try this multiple times. I normally try at least a few times before I'm happy with the results.

if it was easy everyone would do it

This is an effective way to help you center your lettering without stressing how all the words are going to fit. It won't always be 100 percent perfect, but with freehand lettering, it shouldn't have to be.

TIP: If you do feel more comfortable sketching out your quote beforehand, start with the larger/longer words first and work around them, just as if you're doing it freehand. Also, you can remove the majority of the pencil marks with a kneaded eraser so that you don't have to worry about having to erase more pencil marks later on and so they won't show up as much under the watercolor brush lettering or brush pens. One more thing that is helpful is adding printed brush lettering styles to your design, like the serif and sans serif. That way, you can actually start a word with the middle letter and work your way out when trying to center it. I tend to do that a lot to make things easier, and it also looks nice.

Now try brush lettering this quote on the next page. Remember to take your time and count the letters to ensure you center them as well as possible.

Lettering Inside
BASIC SHAPES

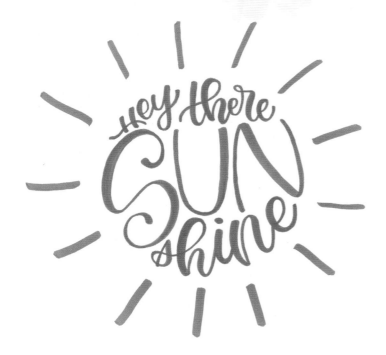

We're going to keep it super simple in this chapter. We'll letter a quote inside a circle and fill the entire space with the letters of our quote. This is a fun technique that comes in handy when you have a particular shape or space to letter in.

When lettering inside shapes, it is a great idea to sketch it out beforehand so that you can fit everything in the most efficient way. There will be times when you'll want to fit all the letters into every nook and cranny, and there will be times you'll want to use embellishments to fill the negative space. Actually, you may even want to leave those spaces blank depending what your final design idea is.

I love filling in all the space so that the shape can be easily identified without an outline. And I love how creative you can be to get to that point.

SUPPLIES TO GRAB

- A drawing compass or something else round (4 inches [10 cm] in diameter) that you can trace around

- Pencil (#2 or HB)

- Kneaded eraser

- Other eraser (I prefer the Pentel Hi-Polymer Eraser.)

- A small brush pen of your choice (I used an orange Sakura Koi Brush Pen.)

STEP ONE

Take your compass or round object, like a large cup or bowl, and lightly trace a circle with your pencil that is about 4 inches (10 cm) in diameter.

STEP TWO

To easily place the words, start with the largest word, or the word that you want to place the most emphasis on, and lightly sketch it inside the circle with your pencil.

In this example you'll start with the main word that will be emphasized: "SUN." This word will be all uppercase letters using the Sans Serif Modern Brush Lettering style (page 31). It will take up the majority of the space inside the circle, which is okay because it's the main word that should stand out.

Start by placing a large U in the middle of the circle, and then, in the same size and style, add the S and N just like in the example. If needed, redo it as many times as you need to so that it fits as snugly as possible. You'll want the left side of the S and the right side of the N to touch the edges of the circle as much as possible.

STEP THREE

Next, add the first two words of the quote to the top section of the circle using Bouncy Modern Brush Lettering (page 26). I modified the letters to fit better in the circle.

Make sure to lightly sketch the letters so that you can modify them as much as you need to. "Hey there" should fit snugly between the top part of the circle and the word "SUN".

You'll notice how I made the H smaller and the e and y larger so that they would fit better. The word "there" also includes a ligature (see page 75) that connects the t and h where the beginning of the crossbar is lower than the end of the y in "Hey" so that they fit better together. The e is smaller and the r is larger as well so they would also fit better in the space provided.

It's all about experimenting when you're trying to get letters to fit. Remember that it's completely normal to keep trying different things and different styles until you get something that works.

STEP FOUR

Now you'll add the last word, "shine," to the bottom of the circle. When sketching this word, stretch the letters from the bottom of "SUN" to the very bottom edge of the circle.

Having all the words line the edge of the circle as much as possible will make sure a circle shape is still visible after you erase the outline.

TIP: If you have trouble fitting the words, even with extra flourishing and swashes, try adding more variations of lettering styles. Mixing styles always gives lettering a fun and unique look.

STEP FIVE

Once you're happy with your design, take your kneaded eraser and remove as many of the pencil markings as you can so that they're just light enough to see.

NOTE: My example has darker pencil marks so that you can see it clearly here, but make sure yours are as light as possible so that it doesn't show too much through the ink of your brush pen.

STEP SIX

Lastly, grab your brush pen and go over all the letters. Make sure that you don't outline the circle. Once you're done, erase all the remaining pencil marks with your other eraser, using light pressure. There's always a chance some of the brush pen ink will lift off when you erase over it.

Add the dashes around the outside of the circle to create the look of the sun. This finishes the design and creates a very happy and bright quote.

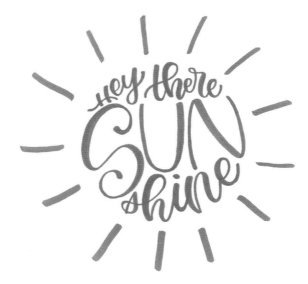

Now that you are familiar with this technique, it will help you easily letter inside other shapes later on too. It's time to create your bright and sunny quote on the next page.

Lettering Inside
SILHOUETTES

Now we're going to step it up a notch and letter inside a silhouette. This is a bit more difficult because you're going to have more complex spaces to fill up depending on the shape you choose. And that could be anything from a bear to a cactus to a tea cup. The choices are unlimited. This is also another popular technique that you may have seen many times before. It's fun and always looks very creative.

We'll be using mixed lettering (see page 49) so that the text will precisely fill the outline of the silhouette for this design.

SUPPLIES TO GRAB

- Pencil (#2 or HB)

- Kneaded eraser

- Other eraser (I prefer the Pentel Hi-Polymer Eraser.)

- Small brush pen, any color (I used a blue Pentel Fude Touch Sign Pen.)

STEP ONE

With this technique, we're going to be using a silhouette of a cupcake. Why? Mainly because cupcakes are awesome. And they're also a relatively easy shape to draw and fill.

I created an outline for you below that you can copy for your main quote.

Lightly sketch the cupcake out with pencil and resketch it if needed until you're happy with the overall shape.

STEP TWO

Now take your quote and fit it into this shape by sketching a few different designs on some scratch paper. Use different styles of lettering if needed and add flourishes and swashes to fill in spaces. If you've tried multiple ways to get your lettering to fit and there's still space left that you want to fill, try additional flourishes (more information on that in the next chapter [page 164]) or even something as simple as making dots, also known as stippling.

For this example, I sketched out the quote for you. Notice that I used mixed lettering (see page 49). I used a script style for the word "life" so that it would fit better in that curve of the frosting at the beginning of the quote.

I stretched the e in "life" too, making the top loop as big as possible to get into that tip of the frosting at the top of the silhouette. I also made the "is" in the Typewriter-Style Lettering (page 35) to give it more interest and visual appeal. You'll notice that the S in "Sweeter" is as round as possible to fit into that curved space of the frosting. And I shaped the crossbar of the t so that it fits well in that space. The R was also modified to fit well in that curve. I tried using the lowercase r but it didn't fit as well as I'd hoped it would. Likewise, I ended with with an uppercase H so that it would take up more space.

I'm hoping that going through some of the process this way will help you understand my way of thinking and will in turn help you when it comes to other projects that include fitting quotes into silhouettes like this.

STEP THREE

Depending on whether or not there's going to be any negative space left over will affect the decision to keep or remove the outline of the silhouette. In this case, I would prefer to keep the outline, since without it, the tip of the frosting would be gone.

Some other ways around that would be to change the shape of the tip of the frosting to follow the shape of the lettering more. Or you could also fill in the space as I pointed out before with stippling or additional flourishes.

STEP FOUR

Now use your kneaded eraser and remove as many of the pencil marks as possible until you can just barely see them. Then take your brush pen and brush letter the quote and outline of the cupcake.

Once you're done, take your other eraser and remove the rest of the pencil marks.

OPTIONAL: Letter the words in the "frosting" area a different color than the text inside the rest of the cupcake for more interest and to further define the shape.

Now it's your turn to practice as much as you'd like in the space below, then create this sweet cupcake lettering on the next page.

Using Flourishes
TO FILL SPACES

In this chapter, we're going to go further into how to completely fill up negative space with flourishes. We tried adding some flourishes to letters a little in earlier chapters, but I wanted to go over it even more to show you how to add random individual flourishes around your quote—not just adding flourishes to letters. We're going to put a quote inside a square and fill the negative space with not only flourishes and swashes that are connected to the letters, but also randomly placed flourishes that we've already learned.

SUPPLIES TO GRAB

- Pencil (#2 or HB)
- T square ruler or regular ruler
- Small brush pen, any color (I used a purple Pentel Fude Touch Sign Pen.)

STEP ONE

First, with your pencil and ruler, lightly outline a 3-inch (8-cm) square on the next page. I prefer using a T square ruler so that I can make sure the lines are as straight as possible.

STEP TWO

Letter the quote inside the square. You'll be using Bouncy Modern Brush Lettering (page 26) for the words "make today" and Sans Serif Modern Brush Lettering (page 31) for the word "AWESOME."

Center it as well as possible using the centering technique from page 153. Start with the word "today" and center it in the middle of the square. Then add "make" right above it and "AWESOME" right below, using the word "today" as your centering guide.

Take your time and try as many times as needed. I always try a few times before being happy with it.

STEP THREE

Now you'll start adding flourishes (page 61) to the words "make" and "today."

Add the flourishes you see in the example below to the letters m, k, e, t and y.

STEP FOUR

Then add the flourishes to the letters A and M in the word "AWESOME" as you see in the example below.

STEP FIVE

Next, since there's a lot of extra space, you'll start adding additional flourishes around the quote to fill in the rest of the square space.

Start with these flourishes.

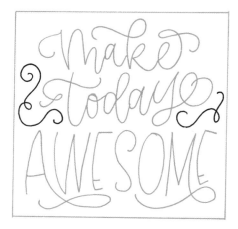

Then add these flourishes.

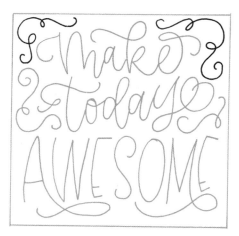

STEP SIX

Continue going around the square, filling up spaces with flourishes. Try and keep them all around the same size. That way, they will look more balanced and pleasing. But if you need to, don't hesitate to change the size of a few flourishes to make sure they all fit.

You can follow what I did in the example below.

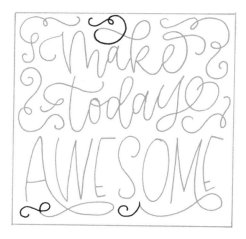

STEP SEVEN

Now that you're done with the initial sketching, take your kneaded eraser and remove as many of the pencil marks as possible so that you can barely see them before going over the words and flourishes with your brush pen. Make sure to omit the square outline.

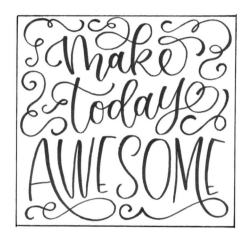

Then take your other eraser and erase all the remaining pencil marks, including the square outline, to complete your final design.

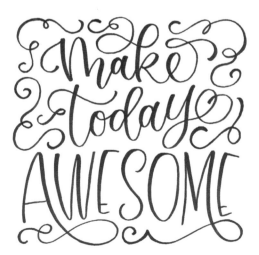

Now you can try this design on the next page. Take your time to get nice smooth flourishes. You can use the space below to practice as much as you need beforehand!

OPTIONAL: If you'd like, you can apply a different color to the extra flourishes you add to the square. Or you can change the color of the word "AWESOME" to make it stand out.

Mixing Lettering Styles
TO FILL SPACES

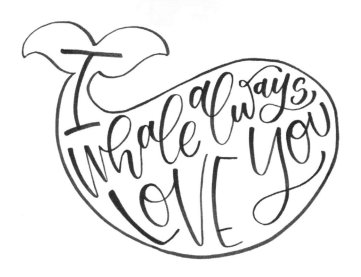

If you remember earlier in the book, I mentioned how much I love mixing lettering styles. You'll be doing the same here to help fill in negative space. With this technique we will be fitting the quote inside a silhouette of a whale. Whales are not only adorable but they are also a fun shape to work with.

SUPPLIES TO GRAB

- Pencil (#2 or HB)

- Kneaded eraser

- Other eraser (I prefer the Pentel Hi-Polymer Eraser.)

- Small brush pen, any color (I used a light blue Pentel Fude Touch Sign Pen.)

STEP ONE

First, with your pencil, lightly sketch out the whale shape pictured below on the next page. Don't apply too much pressure as you're sketching so that if you need to change the shape in any way, you'll be able to do so easier than if the pencil outline were dark.

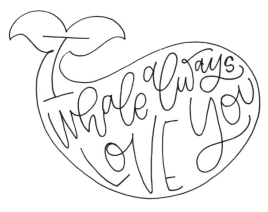

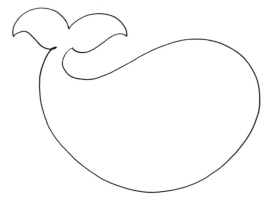

STEP TWO

Take the quote and fit it inside the whale silhouette as well as you can, just like I've shown you in the example.

First you'll letter the I in Serif Modern Brush Lettering (page 31) so that it fits in the tail of the whale.

Then you'll add "Love You" to the bottom of the whale using the technique "Mixing Lettering Styles" (page 49). Make sure it's large enough so that it fits from the left side of the whale to the right side, filling up the entire bottom half. It's okay to have it be a bit larger in size than the other lettering because we want the emphasis on the words "Love You."

Lastly, add the words "whale always," using the Bouncy Modern Brush Lettering style (page 26), to the top half of the main part of the whale. You'll want to fit those words into all the extra space as well as possible. You'll notice that I added a simple flourish to the w in "always" to help fill more of the space there. And I made sure the loop of the y filled as much space as possible above the word "you."

STEP THREE

Once you're done sketching the words, take your kneaded eraser and remove as many of the pencil marks as possible while still being able to see them. Then take your brush pen and trace over the sketch and outline.

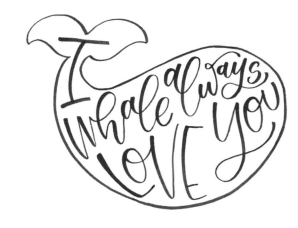

OPTIONAL: Color in the whale to give it even more charm. If you'd like to try this, make sure to color the whale before tracing over the letters with the brush pen, which will prevent the black ink from smearing.

Now follow these steps and have a whale of time on the next page. Have fun with it and definitely try other whale puns in the future now that you know how to fit quotes into fun shapes like this.

Adding Emphasis
MAKING WORDS STAND OUT

In this final section, you'll be learning how to make certain words stand out. These are words that are important and need to be emphasized. Words that you want to make sure people pay attention to when reading your quotes.

These techniques are also great for other things like addressing envelopes. For instance, you could use one of the techniques in this section to make sure the addressee's name stands out more than the address so that it looks more aesthetically pleasing.

Along with emphasizing the words themselves using mixed lettering, block lettering and shapes, you will learn how to grab attention with embellishments. I personally love learning lots of different techniques that are used for the same purpose because that means that I have more choices, and having more choices means my designs are more likely to be unique and original—completely one of a kind.

You will also find supply lists at the beginning of each chapter to ensure you're prepared, and they will continue to be accompanied by step-by-step instructions to help you learn as easily and efficiently as possible.

I hope that throughout this book you have enjoyed learning all the different techniques that were included, and I hope you have fun applying them to your brush lettering. And don't forget: All the techniques in this book can always be used for other projects. Keep practicing, keep trying new things and always embrace creativity!

Using Mixed
LETTERING STYLES
FOR EMPHASIS

One of the things I love doing most in my compositions is using different lettering styles for emphasis, meaning I like to make sure certain words stand out more than others.

I found that an easy way to do this is to use script for the majority of the quote and use sans serif- or serif-style lettering for the words I want to make stand out. I also make sure they are all uppercase so they really pop. I'll even do the opposite for some quotes. If I primarily use sans serif or serif styles, I'll use script to make certain words feel a certain way by giving them a softer or more elegant look. With this quote we're going to use Serif Modern Brush Lettering (page 31) for emphasis.

SUPPLIES TO GRAB

- Pencil (#2 or HB)

- Kneaded eraser

- Other eraser (I prefer the Pentel Hi-Polymer Eraser.)

- Small brush pen, any color (I used a pink Pentel Fude Touch Sign Pen.)

STEP ONE

Lightly sketch out the script style sections of the quote in pencil first, leaving space for the serif-style words. This way you'll have a clearly defined space to add the other lettering.

STEP THREE

Once you're happy with the sketch and like the way all the words are fitting together, go over all the lettering with your kneaded eraser to lighten the pencil marks as much as possible.

Then go over the script-style lettering with your brush pen.

STEP TWO

Then sketch out the serif-style lettering in the empty space, fitting each letter in as efficiently as possible. I like to vary the letter sizes so they fit really snugly together. To do that, just stretch the letters to make them taller or shorter as needed.

STEP FOUR

Finally, use your brush pen to go over the serif-style lettering to complete the quote. Once you've finished going over all the lettering with your brush pen, erase any remaining pencil marks.

Now you try! Practice using mixed styles of letters for emphasis, and then have fun creating the final quote on the next page. Play around and make it uniquely yours!

Using Block-Style LETTERING FOR EMPHASIS

be a UNICORN *in a field of* HORSES

Here we're going to do the same type of technique as we practiced in the last chapter, but we're going to use Block-Style Lettering, which you learned on page 37, for emphasis. You can use this technique with serif-, sans serif- and even script-style lettering.

SUPPLIES TO GRAB

- Pencil (#2 or HB)

- Kneaded eraser

- Other eraser (I prefer the Pentel Hi-Polymer Eraser.)

- Small brush pen, any color (I used a pink and blue Pentel Fude Touch Sign Pen.)

STEP ONE

First, in regular sans serif style, lightly sketch out the entire quote with your pencil, making sure everything is centered and spaced out evenly so it looks balanced.

You can follow the example below.

STEP TWO

Figure out what your most important words are, and those will be the words you'll emphasize with the Block-Style Lettering. Still using your pencil, trace over those words again using the sans serif-style lettering. Make sure there is enough room, but not too much, in-between each letter so that you can easily outline them.

STEP THREE

Then go ahead and outline those letters with the brush pen to create the block letters, making sure all the ends are squared—have sharp corners and are not round. This is what gives them the "block" look.

STEP FOUR

Continuing with your pencil, go over the remaining words again using the Basic Modern Brush Lettering style (page 17), making sure they still fit well around the block lettering.

Make any changes if they're needed, such as moving words around if spacing is uneven between them.

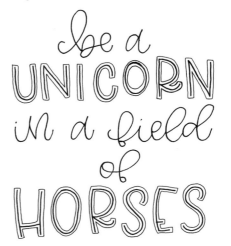

STEP FIVE

Now you'll complete the block lettering by using the basic drop shadow technique (page 116).

Create an imaginary light source, as in past chapters. I have this one located in the upper right-hand corner of my example so the thicker lines will be on the left sides and bottoms of each letter. These shadows will give the block lettering more dimension so they really stand out. This is one of the main reasons why I love using brush pens to create these letters instead of a regular pen. It's so much easier to create these types of effects with just one pen.

To make things easier, you can use my example below to add the same thick strokes to your block letters exactly where I have added.

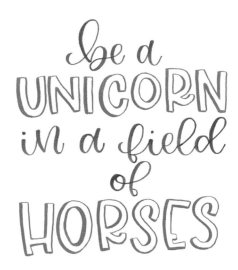

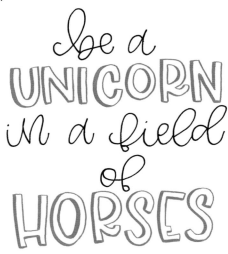

STEP SIX

Then, using your brush pen, go over the rest of the basic modern-style lettering to finish the quote.

Once you've finished and are happy with the results, use your eraser and remove any remaining pencil marks to complete the quote.

Now you can letter this quote on the next page. Feel free to practice here beforehand, if you'd like!

TIP: Double-check your block lettering when you've finished to see if there are any areas that don't have the drop shadows that need them. This actually happens quite often.

OPTIONAL: You can also try adding larger drop shadows and more color to the block letters so that they stand out even more by using the same technique found in Using Color for Drop Shadows (page 116).

Outlining Words
AND USING BRIGHT COLORS FOR EMPHASIS

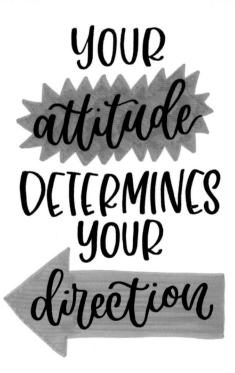

Another way you can really emphasize letters is by outlining complete words and using bright colors to highlight those areas and make them pop! It's a very easy way to bring attention to important words.

SUPPLIES TO GRAB

- Pencil (#2 or HB)
- Kneaded eraser
- Other eraser (I prefer the Pentel Hi-Polymer Eraser.)
- 3 small brush pens, 1 black and 2 other colors (I used orange and green Sakura Brush Pens.)

STEP ONE

First, sketch the quote in pencil below using your regular handwriting so you can easily place all the words and figure out how you want the layout to look. Be sure to center them and space them out as well as possible.

your
attitude
determines
your
direction

STEP TWO

Next, determine which words you want to emphasize and use your pencil to go over them again using the Bouncy Modern Brush Lettering style (page 26).

your
attitude
determines
your
direction

STEP THREE

Take your pencil and go over the remaining lettering using Sans Serif Modern Brush Lettering (page 31). Make sure you leave room around the emphasized letters so you can add the shape outlines around them in the next step.

YOUR
attitude
DETERMINES
YOUR
direction

STEP FOUR

Create a "star burst" outline around the word "attitude," and an arrow around the word "direction" to emphasize them. Make sure your shape outlines don't overlap the other words in the quote.

STEP FIVE

Then, take your kneaded eraser and remove as many of the pencil marks as possible. Remember to always leave just enough so you can see the original sketch. Go over the sans serif lettering with the brush pen, excluding the emphasized words for now.

STEP SIX

Now color in each shape with a bright color. You can use the same color for each outline like I am or use different colors.

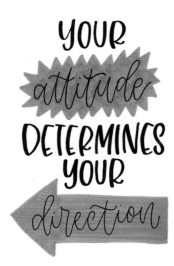

STEP SEVEN

And lastly, brush letter the emphasized words in their colored shapes using the bouncy lettering style. This way, the lettering won't smear from coloring in the shapes afterward.

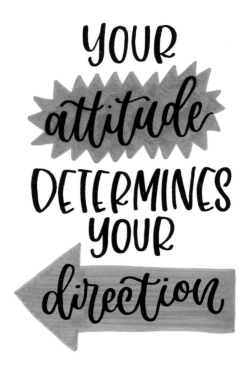

OPTIONAL: Instead of using a bright color to fill in the boxes, change the lettering style inside the boxes to block letters and use a scribble texture to fill in the space around those block letters for a different look and feel.

You can also add that same scribble texture to the rest of the lettering for a complete look by adding an outline to the rest of the letters and using the texture inside those letters.

Now, have fun and create this quote on the next page. Using different shapes with your lettering will give it a whole new and unique look.

Using Embellishments
TO HELP WORDS STAND OUT

Along with changing the way words look to make them stand out, you can use embellishments to add even more interest to them.

SUPPLIES TO GRAB

- Pencil (#2 or HB)
- Kneaded eraser
- Other eraser (I prefer the Pentel Hi-Polymer Eraser.)
- Small brush pen, any color (I used a blue Pentel Fude Touch Sign Pen.)
- Fine tip pen, any color (I used a dark blue Sakura Pigma Micron PN Pen.)

why
fit in
when you
were born
to
STAND OUT

There are many different embellishments you can use. Below are some examples of different types you can try.

In the sample quote we're going to use just a couple to keep it a bit simple.

STEP ONE

First, lightly sketch out just the lettering part of the quote with your pencil, as in the example below. Stack the words just as you see below.

Once everything is sketched out, take your kneaded eraser and remove as many of the pencil marks as possible while still leaving enough to see the original sketch.

why
fit in
when you
were born
to
stand out

STEP TWO

Figure out which words are the important words that you want to stand out. In this case it will be the words "fit in" and "stand out."

Then, using your fine tip pen, draw a simple ribbon for the words "fit in" by following the example below.

And then, with your brush pen, add the words "fit in" inside using Sans Serif Modern Brush Lettering (page 31).

STEP THREE

For the second set of emphasized words, "stand out," you're going to form them using Block-Style Lettering (page 37).

Take your brush pen and use just the tip to outline the sketched letters.

Then you're going to use your fine tip pen to add horizontal lines inside each of the letters to give them interest, just like they appear below in the example.

The word "stand" will have the lines in the bottom half of the word, and the word "out" will have the lines in the upper half of the word.

STAND OUT

Add a drop shadow to the block lettering using your brush pen and the basic drop shadow technique (page 116).

Figure out where your light source is and add the shadows to the opposite side.

In this example we'll have the light source in the upper left-hand corner so that the shadows will be on the right-hand side of each block letter and the bottoms.

STAND OUT

And lastly, you'll add lines to the left and right side of the block letters with your fine tip pen. You'll draw them as if they're coming out from the center of the word.

OPTIONAL: Add a dot to the end of each line that extends away from the words.

STEP FOUR

Now, with your brush pen, add the rest of the lettering using Basic Modern Brush Lettering (page 17).

You'll add the word "why" to the top of the quote above the ribbon.

Then you'll add the rest of the words, "when you," "were born" and "to" stacked on top of each other in between the emphasized words "fit in" and "stand out."

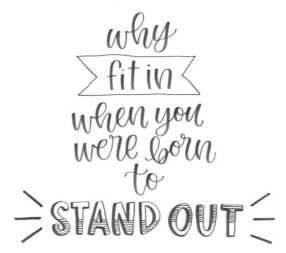

STEP FIVE

Once you're done, you can take your eraser and remove any additional pencil marks.

Now it's time to do your final project on the next page. Experiment with the different styles as much as you'd like until you find your favorites. Take your time and enjoy the entire process.

ACKNOWLEDGMENTS

I am proud of the people I have had in my life who made the process of writing this book not only more enjoyable but worth every moment.

My children—Thank you for putting up with me and my long hours while creating this book and being excited with me. Love all of you always.

Steven—For helping when I needed it and always being there. Love you.

Tyra, Jennie, Shelly, Tiffy, Jo, Chelle, Myriam, Lise and my many many other amazing friends that I've met through lettering—You are all so amazing, and I literally would not be here today, writing this book, without the constant kindness, encouragement and friendship you have all shown me. Thank you from the bottom of my heart.

The Lettering Commuity—To all of you who have let me be a part of your lettering adventures, I am thankful that I could be there. I am so happy that I have been able to share what I know with all of you and that you have all been so wonderful and kind and kept the positivity going.

Liss Amyah—I haven't had the pleasure of knowing you that well, but you were a big part of my getting started with lettering. With the help of your lettering challenges and your kind words on posts that I thought were awful, I found the inspiration to keep going. Thank you so much for making it a great experience since the beginning.

Sarah Monroe and everyone at Page Street Publishing—Thank you all so much for this amazing opportunity to put this book together. It's been a dream of mine for years, and with your continued patience and kindness (which has been way more than I deserve) while working on this book, you have helped make that dream come true. I am so thankful for all of you.

ABOUT THE AUTHOR

Chrystal Elizabeth is a modern letterer. She is most known for brush lettering and modern calligraphy and finds happiness in all things lettering and watercolor. Most of the time she can be found lettering and painting at her desk along with learning new skills and techniques online. She has also had the opportunity to work with companies such as Pentel of America, Sakura of America, BYUtv and JetPens. Some of her other favorite accomplishments are designing logos for different small businesses and designing the lettering for the cover of a young adult novel, along with being featured by companies like Strathmore, the Conklin Pen Company, Monteverde, Coliro and Tombow USA. Whenever she's not consumed by her lettering or watercoloring, she loves hanging out with her kids and boyfriend in the beautiful state of Washington.

INDEX